Master Narratives
and Their Discontents

University College Cork
Coláiste na hOllscoile Corcaigh

Theories of Modernism and Postmodernism in the Visual Arts
A book series from Routledge and University College Cork

James Elkins
General Editor

Master Narratives and Their Discontents

James Elkins

with an introduction by Anna Sigríður Arnar

Routledge
Taylor & Francis Group

NEW YORK AND LONDON

Published in 2005 by
Routledge
Taylor & Francis Group
270 Madison Avenue
New York, NY 10016

Published in Great Britain by
Routledge
Taylor & Francis Group
2 Park Square
Milton Park, Abingdon
Oxon OX14 4RN

© 2005 by Taylor & Francis Group, LLC
Routledge is an imprint of Taylor & Francis Group

Printed in the United States of America on acid-free paper
10 9 8 7 6 5 4 3 2 1

International Standard Book Number-10: 0-415-97269-8 (Hardcover) 0-415-97270-1 (Softcover)
International Standard Book Number-13: 978-0-415-97269-7 (Hardcover) 978-0-415-97270-3 (Softcover)

Library of Congress Cataloging-in-Publication Data

Catalog record is available from the Library of Congress

Taylor & Francis Group
is the Academic Division of T&F Informa plc.

Visit the Taylor & Francis Web site at
http://www.taylorandfrancis.com

and the Routledge Web site at
http://www.routledge-ny.com

Contents

Plates

Series Preface

There is a gap in accounts of modern art. Some of the best historical work has been done by scholars who have not wanted to contribute to the large-scale questions of what modernism might be, or how nineteenth-century art might fit in the lineages that lead to postmodernism. That is one side of the gap. On the other is a common pedagogic literature intended to introduce modernism to beginning students; it is generally not written by the scholars whose work is central to the developing discipline, and it is not often cited. Between these two extremes there should be a kind of writing that is at once attentive to the fine grain of history and responsive to the different and often contentious accounts of modernism as a whole. Such writing is rare, for a variety of reasons — some of which are embedded in the ways modernism itself has been understood. So far there have only been a few exceptions, notably T.J. Clark's *Farewell to an Idea* and the multiply-authored *Art Since 1900*. Aside from those two enormous, contentious, and problematic texts, there is almost nothing between the sides.

In this series major scholars in the field consider the shape of the twentieth century: its essential and marginal moments, its optimal narratives, the strengths and weaknesses of its self-descriptions. I hope that the series as a whole will be helpful for those who find, as I do, that it can be revealing to put a little pressure on the assumptions that are made in everyday scholarship regarding what is, and isn't, crucial to an understanding of twentieth-century art. There is a growing scholarship, for example, on surrealism and its afterlife. In what ways does that scholarship imply that a version of surrealism is central to a description of some contemporary art? Or to take another example: How does cubism sit with accounts that rely on modernism's political aspirations? Where is Greenberg, his ghosts or avatars, in current historiography?

Large questions like these are the subject of this series. If we do not try to assemble the best theories, winnow the worst, and prepare a clear collation, then what does it mean to continue to write art history in an age of increasing pluralism? I hope it means more than playing in an era that is happily "after the history of art," in Arthur Danto's phrase.

I have mixed hopes for this series. On the one hand I doubt the ideas these authors set out will comprise a consensus, or even a satisfactory survey. On the other hand I believe that there is not an indefinitely large number of cogent, informed, and committed versions of how the century went: on the contrary, I think only a handful of separate and simultaneous conversations

sustain our sense of what modernism was, or is, and it is possible to gather and compare them.

A parallel might be made to physics here: physics turns on what are called GUTs (grand unified theories) and TOEs (theories of everything), in the sense that physicists work with those possibilities always in mind, so that the smallest theoretical demonstration or technical innovation gains significance by its potential connection to the literally larger questions. In the event, many things may happen to physics before the small-scale result can ever effect its ideal theoretical impetus, but that does not vitiate the fact that in physics it is absolutely crucial that large-scale theories exist to drive local inquiries. Art history is different in many ways, not least in that art historians need not think of large-scale problems at all. Yet in art history, reticence regarding larger problems is sometimes taken as a virtue, and that, I think, is questionable. It is as if the most prominent physicists — the Steven Weinbergs or the Stephen Hawkings — were silent about the basic laws of physics. Or as if the most active and creative physicists were committed to looking only at specialized phenomena, leaving the form of the physical world, and the direction of physics, to others as a matter of speculation. What I mean to suggest is that there is a point beyond which attention to the fine structure of historical events is no longer the necessary virtue of good historical work, but rather becomes a strategy of avoidance that can threaten the coherence of the enterprise as a whole. In that sense "larger" questions are not

unhelpfully large or irrelevantly large, as they tend to be taken
to be, but crucially large.

The risks of avoiding going on the record about larger
questions of twentieth-century art are nicely illustrated by a
recent exchange involving the English critic Julian Bell, the
American art historian Michael Fried, and the nineteenth-
century German realist painter Adolf Menzel. In the London
Times Literary Supplement, Bell reviewed Fried's book on
Menzel, praising Fried's readings of individual works and his
rigor, but remarking that it is unfortunate Fried chose not to
connect this book, his first on a German artist, with his decades
of work on the French tradition. How is Menzel linked, Bell
wonders, to the sequences of French painters that Fried has
studied in the past? How is modernism affected, if at all, by this
alternate genealogy? They are good questions, hastily posed but
essentially accurate. Menzel is not, cannot be, an isolated figure
somehow beyond the streams of modernism, if only because the
critical terms Fried has brought to bear on modernism figure
throughout his book on Menzel, driving Fried's inquiries and
informing his judgments. It is the aim of this series to provide a
space where challenges like Bell's can be taken seriously without
becoming either ephemeral polemics or floating generalizations
of the sort most useful to first-year students.

The books in this series were originally lectures, each given on
two successive evenings, at the University College Cork, Ireland,
over a period of three years from 2004 to 2006. Each pair of

lectures was followed by a seminar discussion, part of which is included in each book. The authors were encouraged to respond to previous efforts: the notion was that the series might grow to resemble a protracted exchange, in which each person has months or years to consider how to respond to what has been said. That speed seems entirely appropriate to a subject as intricate, and as prone to overly quick assertions, as this.

I wrote the first book in order to provide a preliminary survey of the field, although I avoided describing the work of the authors in the series. That absence shouldn't be taken as a lack of interest (the opposite is true): it is meant to provide a fruitful starting place for meditations I hope will follow. Readers may begin the series with any book, but taken as a whole, and read in sequence, the series is intended as perhaps the world's slowest, and I hope best-pondered, conversation on modernism.

— J.E.

Introduction

In surveying the vast number of publications written by James Elkins, one cannot avoid feeling awed or even bewildered by the staggering variety of subjects that he has addressed with such passion. From seemingly banal or ordinary objects (e.g., maps of the London Underground, educational picture boards) to arcane or difficult bodies of knowledge (e.g., spider web formations, crystallography), to traditional art historical subjects (e.g., Michelangelo, Jan Van Eyck), nothing appears to have escaped his hungry eye or astute analysis. It is not too much of a stretch of the imagination to envision Elkins perfectly at ease in a seventeenth-century Wunderkammer complete with a stuffed alligator suspended from the ceiling, lush oil paintings on the wall, and cabinets stocked with treasure troves of ancient coins, maps, rare gems and fossils, skeletons and anatomical specimens of all varieties, early optical instruments, alchemical treatises, and the like. I am

not suggesting that Elkins delights in eclectic wonders for their own sake, but I argue that his scholarly work, like the work by some of the individuals who assembled early modern Wunderkammern, has been consistently devoted to exploring the spaces that lie between diverse and even far-flung fields of study. From this interstitial perspective, he examines the relationships and productive encounters (or clashes) between disciplines in a truly imaginative manner. What unifies his diverse range of inquiry is the desire to understand how these disciplines intersect (or diverge from) art historical conventions and practices — including the traditions of making and interpreting images. Above all, his inquiries are made timely and relevant because they are inflected by a sustained familiarity with major philosophical and cultural discourses from the early modern era through the present age. Within this context, he poses challenging and fundamentally pragmatic questions about the nature of art history: What are the unique traditions of the discipline and where do they come from? What are its blind spots and its most valuable contributions to the hermeneutic enterprise? And finally, how do the respective strengths and shortcomings of art history inform the way we practice and teach it today?

When Elkins attended graduate school in the 1980s, fundamental questions of historiography and especially pedagogy in art history were decidedly unfashionable subjects

in most art history departments in the United States.[1] To be sure, there was (and there still is) a great of deal of interest in methodology and hermeneutics from outside the discipline. Literary scholars in particular provided art historians with exciting models of analysis from the fields of semiotics, deconstruction, Marxism, anthropology, feminism, and psychoanalysis, to name but a few of the primary examples. Art history embarked on a journey that entailed not only an expansion of its boundaries and procedures of study but also a profound and often self-flagellating critique of its methodological assumptions. It was a decade of tremendous excitement and inner turmoil: art history was undergoing a "crisis."[2]

By the close of the 1980s, there were calls to sharply revise or entirely abandon what were seen as old-fashioned tenets of connoisseurship, monograph writing, iconography, and stylistic analysis. In short, the object and methodologies of art history were considered to be too mired in positivistic thinking and rigid, historicist frameworks to accommodate productive

1. Prior to 1985 there were very few books in the English language devoted to the historiography of art. A few exceptions that come to mind include the classic work by W. Eugene Kleinbauer, *Modern Perspectives in Western Art History: An Anthology of 20th-Century Writings on the Visual Arts* (New York: Holt, Rinehart and Winston, 1971); Michael Podro, *The Critical Historians of Art* (New Haven, CT: Yale University Press, 1982); and Michael Ann Holly, *Panofsky and the Foundations of Art History* (Ithaca, NY: Cornell University Press, 1984).
2. An entire issue of *Art Journal* was devoted to this crisis in 1982. See Henri Zerner, "The Crisis in the Discipline," *Art Journal* 42, no. 4 (Winter 1982): 279–325.

self-scrutiny.[3] A corresponding quandary developed for those scholars engaged in pure theoretical activity as they increasingly exhibited discomfort before the object of art. In essence, the discipline of art history seemed to be suspended awkwardly between an artificial either–or dilemma — either one worked with art objects within a matrix of established methods or one "did" theory.

As a recipient of a freshly minted master's of fine arts in painting, Elkins entered into graduate studies in art history acutely aware of the tensions that exist between the objects that art historians study and the texts that they write about them. The critical debates about the failures of art history's methods clearly interested him, but he was as devoted to the critiques of art historical procedures as he was to understanding the historical context that framed those procedures in the first place. It seemed inadequate to denounce the assumptions of a field without probing the history of those assumptions or analyzing

3. Some exemplary critiques from the late 1980s include Norman Bryson's introductory essay in *Calligram: Essays in the New Art History from France* (Cambridge, England: Cambridge University Press, 1988). Here Bryson targeted perceptualist accounts (exemplified in the work of E.H. Gombrich) and Social Art History for their respective occlusion or over-simplification of power as a discursive force. Also from this same time period is Donald Preziosi's *Rethinking Art History: Meditations on a Coy Science*, which provided an extended critique of art history's legacy of avoiding rigorous self-scrutiny. From a different perspective, Hans Belting's 1987 book *The End of the History of Art?* (originally published in German in 1983) offered influential critiques of art history by focusing on the divisions within the discipline rather than on its separation from other hermeneutic practices in the humanities and social sciences. Belting defined this internal division as the breach between modern art and historical art, and he argued that these two areas of inquiry endangered themselves by operating under distinct and often contradictory paradigms; *The End of the History of Art?* trans. Christopher Wood (Chicago: University of Chicago Press, 1987).

their broader philosophic and hermeneutic applications. While still a graduate student, he published the provocative 1988 essay "Art History without Theory" in the journal *Critical Inquiry*. In this essay, Elkins examined the Hegelian theories that shape most art historical narratives and the empirical methods that define much of art historical practice. The value of his examination is the articulation of a third position located alongside the vexed dichotomy between theory and praxis. In this schema, theory and praxis are submitted to productive scrutiny and examined in relation to one another rather than in antagonistic opposition. As such, Elkins defined these two elements as engaged in a delicate act of complementarity and contradiction as they define each other's boundaries in art historical scholarship. This delicate relationship constitutes a veritable conundrum: "theory seeks to engulf practice by denying that practice advances as it accumulates facts; and practice denies the constraints that theory would apply to it."[4] Theory, Elkins concluded, is not so much replaced in art history by practice as it is displaced: the two do not intertwine but rather tend to exist in separate yet interdependent zones in the majority of art historical texts.

Although "Art History without Theory" is an early work, it encapsulates many of the analytical strategies and themes of Elkins's later work. First and foremost, it displays his passion for dissecting ideas or hermeneutic problems. In this case, he has performed an

4. James Elkins, "Art History without Theory," *Critical Inquiry* 14, no. 2 (Winter 1988): 357.

anatomy lesson of sorts to expose the relationship between theory and praxis in art history. This lesson is performed as an opportunity to examine closely a problem rather than offer clear-cut judicative pronouncements or solutions to the problem.[5] There is a tone of detached amusement as he ponders the truly curious nature of art history — it is a uniquely hybrid discipline positioned between aesthetic objects and historicist ideals and practices. These stubborn idiosyncrasies and the wonderful strangeness of art history continue to fascinate Elkins, and much of his subsequent work has been devoted to examining and challenging them in detail.

In the decade and a half since the publication of this 1988 essay, there has been a sharp increase in the number of books and articles devoted to the historiography and methodologies of art history. Never before have art historians been more intensely aware of their disciplinary traditions, their methods, their shortcomings, and, perhaps only more recently, their strengths. Given the abundance of voices on these matters, how can we characterize Elkins's unique contribution? For starters, he has forced those of us engaged in the activity of interpreting pictures to confront subjects that have been either overlooked or deemed too unwieldy, difficult, or simply embarrassing. He is only too happy to articulate our deepest anxieties or failures with respect

5. Elkins makes reference to the useful language of anatomists for describing this particular form of analysis. He explains that the term prosection is a dissection procedure that exposes the organ but leaves it intact, as opposed to an excision or resection that removes the organ in whole or in part; "Art History without Theory," 368.

to the elusiveness of art objects or regarding some of the fragile but well-intended ambitions that have informed recent attempts to update "normal" art history (a term he uses to define mainstream art historical practice).

Elkins has described himself as a "hobbler of narratives" and, as such, he likes to throw a wrench into the interpretative process. Nowhere is this characterization more evident than when he invokes the ineffable yet inescapably physical conditions of art making — painterly blobs or "sticky goo" (an expression one of his students coined to describe the feeling between his ears when he paints), for instance, have a tendency to disrupt hermeneutic models of analysis because they cannot be easily translated into terms that are compatible with those models. To drive his point home, he thrusts his readers into the artist's studio, a space that Elkins characterizes as

> the place most feared and excluded by visual theory and art history: it has virtually no part in philosophic accounts of art, and it has only a limited role in art history. ... There are both historical and philosophical reasons for that exclusion: studio practice is difficult to connect to historical themes, since the personal and largely inarticulate discoveries made in the studio do not seem applicable to finished works that exist in history; and studio talk is riven by ungrammatical arguments, illogic, and nonverbal communication by gestures and marks that conspire to make it nearly illegible to philosophic inquiry.[6]

6. James Elkins, *Our Beautiful, Dry, and Distant Texts: Art History as Writing* (New York and London: Routledge, 2000 [1997]), 47.

Even for art historians who teach in studio art departments (such as me) and have spent considerable time in and around studios, there are moments when it feels as if artists inhabit a parallel and distinctly "other" universe (the feeling is mutual, of course!). I might share their passion for an art object, but our respective reasons for doing so and the language with which we express those passions seldom intersect. These differences are typically amplified when one turns to the activity of interpretation — the very impulse to interpret is often considered alien or contrived by some of my studio colleagues. As I see it, Elkins does not intend simply to hobble academic inquiry of art works by invoking the artist's studio; he also wants us to consider why so many of our interpretative models need to function outside this space. In accepting Elkins's challenge to enter this space and take into account the seemingly quirky or inarticulate practices of the studio, we ultimately gain an attempt to understand — or better yet, savor — those moments when theory and praxis are at loggerheads.

It is precisely in this zone of conflict and contradiction where Elkins wants us to linger. His efforts to slow down the interpretative process are driven by the desire to engage and appreciate the difficulty and complexity of this process. In his book *Pictures and the Words That Fail Them*, for example, he warned,

> Too often, reading the art historical literature, it can seem as if pictures are relatively easy to write about, to put into words. Certainly interpretations might be hard to come by, and it can be trying to arrange

> the evidence in a convincing manner, but it appears as if pictures themselves present no problems: everyone knows how to apply theories to them, how to describe them, and how to pose and solve problems about what they mean. What gets lost here is the picture as picture, as a mute collection of funny-looking smears and shapes that somehow lends itself to practically endless streams of eloquent historical writing. This book is an attempt to make pictures more difficult.[7]

In "making pictures more difficult" and hobbling our smooth, interpretative narratives, Elkins creates skillful digressions designed to provoke thoughtful scrutiny or the sheer pleasure of contemplating objects with their incoherent or elegant surfaces and marks. These digressions are purposeful "meanderings" that delight in the "muddle, the tangle of crossing paths" of conflicting interpretive arguments.[8]

Many of Elkins's meandering analyses lead us face-to-face with the idiosyncratic traces, splatterings, or blurs of a picture's surface. By getting up close and personal, we are once again in that zone where theories of art seem to buckle or fade before the materiality of the picture, and, consequently, according to Elkins, we are in a much more interesting place. Consider, for example, his discussion of the inherent difficulty in isolating individual marks of a picture and determining their relation and function to surrounding marks and surfaces. He deploys the term exfoliate to describe the process and appearance of a mark's

7. James Elkins, *On Pictures and the Words That Fail Them* (New York: Cambridge University Press, 1998), xi.
8. Elkins, *Our Beautiful, Dry, and Distant Texts*, 176.

fluctuating status: "Marks exfoliate ... by drawing attention to
their boundaries, so that the boundaries become outlines in their
own right: and when that happens, the boundaries themselves
can be perceived as marks, turning both the original mark and
the original surface into surfaces."[9] By closely examining
the instability of the mark, Elkins points to a fundamental
incompatibility between written signs and painted or drawn
marks and thereby challenges some of the basic assumptions
that underlie the semiotic analysis of pictures:

> Unlike written signs, drawn and painted marks are insecurely linked
> to their grounds, and the same is true at the level of the figure — a
> fact that has to be suspended in order to get on with art historical
> interpretations that treat figures as if they were signs detachable from
> their grounds.[10]

Despite Elkins's lingering, close-up examinations of marks,
he does not perform a wholesale dismissal of visual semiotics;
rather, he insists that we confront the moments of contradiction
and difficulty that can arise from looking at — but not
necessarily fully understanding — pictures. Just as semiotic
analyses upended certain self-assured empiricist claims in art
history, Elkins wants to momentarily arrest semiotic readings of
pictures that are at times equally self-assured.

Elkins has clearly relished playing the devil's advocate
by insisting that interpreters of pictures take a closer look

9. Elkins, *On Pictures and the Words That Fail Them*, 26.
10. Ibid., 43.

at studio practice or at pictorial marks. But his impish provocations are not always launched from an up close material perspective. He frequently zooms in and out from the object to reposition his argument from a more distant perspective by examining the trajectories of a particular philosophic discourse, scientific theory, or complex issue in historiography. In other words, his analyses can be simultaneously astringent and capacious in their focus, and these shifting registers have gotten Elkins into trouble on occasion and provoked conflicting critical responses to his work. How many scholars, after all, have been characterized as being too historical, transhistorical, nonhistorical, and ahistorical at the same time?[11]

The vertical register of Elkins's scholarship is matched in intensity by the horizontal range of his subjects — prehistoric artifacts, Renaissance drawings, Ancient Chinese bronze vessels, and contemporary paintings, for example, have all been submitted to intense analysis from near and far. Although his

11. By his own admission, Elkins refers to the problematic occasioned by his own "conditional release" from history in some of his analyses. James Herbert, for example, described the fundamental nonhistorical framework in *The Domain of Images* that put into play "the difference between intermittently historical, nonhistorical, and ahistorical"; personal communication recorded by James Elkins in his review of *Real Spaces: World Art History and the Rise of Western Modernism*, by David Summers, *Art Bulletin* 86 no. 2 (June 2004): 380, n. 26. Robert Williams is more troubled by Elkins's release from history, stating that "historicity of art is essential to its interest" and that "any fully-developed, intellectually rigorous approach to art must be fundamentally and not incidentally historical"; Robert Williams, "Sticky Goo," *Oxford Art Journal* 25, no. 1 (2002): 102. Mieke Bal takes quite a different stand, referring to art history's "naive historical dogmatism" and obsession with origins, but she also accuses Elkins of being "transhistorical." See her "Semiotic Elements in Academic Practices," *Critical Inquiry* 22, no. 3 (Spring 1996): 587, 589.

capacity to analyze a problem or an object from a multitude of positions makes it difficult to pin him down methodologically and ideologically, this kind of mobility makes him uniquely qualified as a kind of cartographer of ideas and hermeneutic practices. Recently, he has deployed this unique skill to map the range of interpretative strategies that have been put into practice in art history over the years. In this map he traces the broad contours of these strategies and their specific textures to create a useful tool for analysis. In *Stories of Art*, for example, he takes on one of the most permanent fixtures of art historical teaching: the art history survey textbook. In what I consider to be a typical gesture in Elkins's work, he does not simply enumerate the myriad approaches employed by textbooks; he maps the different shapes of their narratives. Ideas are no longer abstract claims but tangible positions that can be mapped for close examination and situated relationally within a broader matrix of narratives. As in the case of the cherished crystals mentioned in a number of Elkins's writings,[12] determining their complex patterns and structures provides a means of classification, but this activity is equally useful for comparative analysis. And here I might add that he has not shortchanged us on the range of sampling for this analysis — not only do we encounter the well-documented art

12. See, for example, Elkins, *The Domain of Images* (Ithaca, NY: Cornell University Press, 1999), 13–30; and *Visual Studies: A Skeptical Introduction* (New York and London: Routledge, 2003), 83–86.

historical narratives (Vasari, Gombrich, Gardner, Stokstad) but we also are provided with one of the first comparative analyses of non-European narratives including Russian, Chinese, Iranian, Egyptian, and Turkish art history survey textbooks.

Stories of Art, however, is by no means a dispassionate map of classifications and topographic comparisons. Elkins deftly penetrates these wide-ranging narratives and momentarily inhabits them to parse their respective merits and flaws. Above all, the entire enterprise is designed to generate serious discussion about the very reasons we teach art history and why we consider it to be a valuable contribution to a liberal arts education. In this sense his text serves as a kind of calculated irritant because it brings to the fore some of the compromises or illusions that we have had to embrace in the attempt to broaden the standard art history survey text.[13] By interjecting sections on non-Western art, women, and minority artists, he argues, we do not fundamentally alter the standard Western-oriented narrative. Elkins is certainly not the first individual to make this critique, but he is certainly far more unflinchingly direct when he enumerates the primary reasons for this failure: (1) "art historians do not really want multiculturalism," (2) "multiculturalism, even in theory, is impossible anyway," and (3) "art history, as an enterprise — an activity that generates jobs and fills seats in

13. Elkins refers to a kind of acid test to determine the strength of a given model. Inevitably the softer models erode with this kind of test. See "Nine Modes of Interdisciplinarity for Visual Studies," *Journal of Visual Culture* 2, no. 2 (August 2003): 236.

classrooms — is irremediably Western."[14] Although he follows up these points with further discussion and examples to solidify his argument, he is keenly aware that a number of readers will disagree with him — but this does not distract from his overall goal of ensuring that we remain somewhat unsatisfied with the provisional alternatives that we have created. Moreover, he encourages us to continue interrogating art history's limits and our motivations when we craft a story of art.

A similarly provocative tone animates his subsequent book *Visual Studies: A Skeptical Introduction.* As in *Stories of Art,* he provides a useful map of definitions and practices in visual studies and visual culture. Throughout the entire text an eclectic array of photographs punctuates his discussion and segues into independent meditations on a staggering range of visual subjects and phenomena. Taken separately, these images constitute a sizable catalog of potential subjects for visual studies. If this book is skeptical about visual studies, the skepticism is not aimed at this discipline's rich potential; rather, it aims squarely at the formulaic and often rushed interpretation of images that defines much of mainstream practice (although he is careful to acknowledge individuals who have invigorated the discourse). As in his earlier works, Elkins seeks to hobble standard interpretative frameworks, and he is particularly successful in doing so in the chapter "Ten Ways to Make Visual Studies More Difficult."

14. Elkins, *Stories of Art* (New York and London: Routledge, 2002), 147.

In this chapter, which forms the cornerstone to the book, he repeatedly urges his readers to not shortchange themselves in the practice of visual studies by resorting to the same interpretative texts and the same repertoire of subject matter. Although each of the ten ways offers inspired prescriptions, I am particularly struck by the last one, titled "The Case of the Writing Itself: The Challenge of Writing Ambitiously," where he encourages writers and especially students considering the field of visual studies to "know the entire field or as much as you can manage" and to "read absolutely everything." Most revealing, however, is the plea to engage with the reading: "Do your sources the favor of a concerted encounter. Compare your thoughts to everyone's."[15]

In his nonconformist spirit and ambitious program of rigorous engaged reading, Elkins possesses a similar kind of scholarly commitment as that of Barbara Stafford, one of his mentors at the University of Chicago. Elkins has paid tribute to Stafford's pioneering scholarship in a number of his texts,[16] but her influence on his work has not been thematic or strategic but rather a case of influence by example — or influence as a source of inspiration. Like Stafford, Elkins exhibits an unwavering passion to become not only well

15. Elkins, *Visual Studies*, 120, 121.
16. See, for example, Elkins's sensitive review of Barbara Stafford's 1991 book: *Body Criticism: Imaging the Unseen in Enlightenment Art and Medicine*, by Barbara Stafford, *Art Bulletin* 74, no. 3 (September 1992): 517–20. More recently, he cited Stafford's writings as a bold example of interdisciplinary scholarship in "Nine Modes of Interdisciplinarity for Visual Studies," 235–36.

informed but also deeply informed on all subjects that intersect his scholarly project. There are no shortcuts to this kind of research program, but the rewards are great because one can genuinely reorient prevailing scholarly discourse to new and exciting terrain. More important, with this kind of depth and breadth of knowledge, Stafford and Elkins have developed the useful ability to speak with a double voice — one voice speaks from within art history, where it offers incisive and pragmatic critiques of the discipline; the other addresses academic disciplines outside of art history and articulates brilliant defenses of art history's unique contributions to understanding the place and function of images within early modern and contemporary cultures.

I also identify in Elkins's scholarship the critical spirit of engagement that typifies some of W.J.T. Mitchell's work or, more broadly, that of *Critical Inquiry*. It was *Critical Inquiry*, after all, that published the infamous series of critiques and ripostes generated by Steven Knapp and Michael Benn Michaels's essay "Against Theory" at a time when Elkins was just beginning his own inquiries into the role of theory in art history.[17] Here again, I am not attempting to trace any kind of direct influence on Elkins's thought but rather attempting to provide a framework for understanding some of the

17. These classic essays were subsequently published in a single volume in 1985; W.J.T. Mitchell, ed., *Against Theory: Literary Studies and the New Pragmatism* (Chicago: University of Chicago Press, 1985).

intellectual ambitions for initiating productive provocation in one's scholarship. In publishing "Against Theory," the editors of *Critical Inquiry* were interested not in endorsing a particular view of theory or in embracing a comfortable position of theoretical pluralism but in unsettling positions that were at risk of rapidly becoming settled. Provocation, then, has the merit of triggering rigorous debate and, in its better moments, as Mitchell observes, "an articulation of unsuspected insights."[18]

Provocation and spirited dialogue are at the heart of Elkins's present text. *Master Narratives and Their Discontents* is designed as a catalyst for "an extremely protracted exchange" and, ideally, the "best-pondered conversation" on modernism and postmodernism. Elkins has once again deployed his familiar strategy of slowing us down to dissect seriously the internal contradictions or the unexamined assumptions that have long framed the discourse on modernism and its shape of twentieth-century art. As such, his inaugural lecture begins with a deceptively self-evident problem: Why are there so few theories in art historical literature to account for the history of twentieth-century art? And why are art historians so reluctant to deviate from these few theories?

Unlike recent arguments in literary, historical, and philo-sophical scholarship that seek to reframe the classical theories of

18. Ibid., 3.

modernism in terms of modernity, autonomy, or the problem
of aesthetic experience,[19] Elkins is resolutely focused on the
primary narratives that have determined the canon of artworks
inscribed in the history of twentieth-century art. In other words,
he finds it genuinely perplexing that despite the existence of
different models to account for this history, the essential list of
important works remains more or less the same. Significantly, as
Elkins points out, those few narratives that do radically alter
the prevailing models for twentieth-century art are, by and
large, located outside academic or pedagogic literature —
such as gallery exhibition brochures, newspaper reviews, and
basic promotional literature. As a consequence, his catholic
embrace of such a surprising range of sources in this inaugural
lecture offers unorthodox juxtapositions: Rosalind Krauss and
Yve-Alain Bois's *Formless: A User's Guide* figures prominently in
his discussion, as do newspaper reviews from the Sunday *New
York Times* or ephemeral information gleaned from commercial
art Web sites.

19. Vanessa Schwartz and Jeannene Przyblyski, for instance, proposed that "modernity" rather
 than "modernism" is a more useful way of examining the major developments in modern
 visual culture in *The Nineteenth-Century Visual Culture Reader* (New York and London:
 Routledge, 2004). "Modernity" rather than "modernism" is also the preferred rubric in
 an art history symposium sponsored by the University of Pittsburgh, "Modernity and
 Contemporaneity: Antinomies of Art and Culture after the 20th Century," featuring such
 influential theorists of modernism as Rosalind Krauss, Fredric Jameson, and Geeta Kapur,
 among others. For the renewed interest in the problem of autonomy and aesthetic experi-
 ence, see Jacques Rancière, "The Aesthetic Revolution and Its Outcomes: Emplotments
 of Autonomy and Heteronomy," *New Left Review* 14 (March–April 2002): 133–51; and
 Fredric Jameson, *A Singular Modernity: Essay on the Ontology of the Present* (New York:
 Verso, 2002), esp. 173–78.

In navigating such eclectic sources, Elkins's seasoned carto-
graphic skills become especially useful: despite the plethora of
material, he maps coherently the primary narratives of twen-
tieth-century art into four basic categories: (1) Modernisms,
(2) Postmodernisms, (3) Politics, and (4) The Importance of
Skill. These categories function essentially as broad guidelines
or descriptions rather than extended evaluations or critical
judgments. This strategy is deliberate. In the series preface he
explains that he hoped to establish a "preliminary survey of
the field" to "provide a fruitful starting place for meditations."
In this sense, the lecture series and the resulting volumes are
genuinely unique in that they capture an ongoing dialogue and
critique of this initial map as well as the subsequent responses
generated by it. In other words, the *Lectures in the Theory of
Modern and Postmodern Art* is not a collection of lectures by
individual scholars over time (such as the *Mellon Lectures*), and
it is not a collection of one-time meditations on subjects chosen
by a selected honorary lecturer (such as the *Norton Lectures*).
Instead, we are confronted with a series of lectures by select
scholars responding to a common problem. This common
problem is subsequently refracted and "thrown into relief" by
the specific textures of individual scholars and their respective
ideologies and methodologies. The desired outcome of this
series is not a universal synthesis or consensus of opinion but
rather a map that encompasses the invigorating course of genu-
ine argumentation.

Much of Elkins's career has been a testimony to stimulating conversation and argumentation on fundamental issues within a variety of contexts. His commitment to this ideal is evident in the nature of his publication record — he is a scholar who has produced provocative publications for the general public (*Pictures and Tears*; *What Painting Is*) and for academic specialists. In this latter category I am struck by the variety of disciplines he has addressed outside the field of art history: his articles have appeared in journals as diverse as *Psychoanalysis and Contemporary Thought*, *Computer Graphics*, and *Current Anthropology*, to name but a few examples. I mention this achievement as a way not only to celebrate his productivity but also to underscore his genuine dedication to engaging a broad and diverse readership — and to do so in the form of exchange. In light of this goal of critical engagement, I might add that several of his publications are rhetorically poised as invitational arguments and framed as questions: "Who Owns Images: Science or Art?" or *What Happened to Art Criticism?* Most important, however, is the fact that many of his writings have been sparked initially by his response to the work of other scholars. He is stimulated by works that are powerful yet somehow incomplete or perhaps overly assured. As a consequence, he wants to revisit those moments of oversight as a means to expand analysis of a particular problem rather than offer a simple correction. He is equally inspired, as he is in this present lecture, when existing scholarship is silent on a particular issue. Whatever gaps or deficiencies are identified

by Elkins, he critiques them not in a spirit of one-upmanship but in hope of engaging present and future readers in thoughtful and spirited conversation.

Hans Aarsleff once characterized conversation between individuals as central to the German romantic enterprise.[20] Novalis, for example, apparently made little distinction between speaking and thinking — conversation was the primary source that fueled his creativity. Although I certainly do not align Novalis's romantic idealism with Elkins's current project, I do think that Elkins's earnest desire to encourage conversation between scholars (and between disciplines) is genuinely motivated by the sheer love of (and need for) exchange, and ideally an exchange that leads to a transformation of prevailing frameworks. This kind of productive conversation values the art of argumentation as a fundamentally creative endeavor. As such, arguments assume distinct shapes and become far more compelling when they are formed by the push and pull of exchange.

Having made allusion to a creative process that implies collectivity and partnership, I do not believe that Elkins envisions the forthcoming conversations to be overly polite, subdued affairs. My guess is that he looks forward to difficult yet engaged encounters — especially those that propose to meander in unexpected terrain.

<div align="right">

Anna Sigríður Arnar
Moorhead, MN

</div>

20. Hans Aarsleff, "After the Fall," *The New Republic*, December 31, 1990, 41.

Anna Sigríður Arnar is an associate professor of art history at the Minnesota State University–Moorhead (United States). She received her Ph.D. in art history in 2000 from the University of Chicago, where she specialized in modern European art and French literature. Her current projects include an essay on the performance artists, the Icelandic Love Corporation, and a book manuscript titled *Facets: The Book in the Work of Stéphane Mallarmé.*

Master Narratives and Their Discontents

Let me propose that the history of writing on twentieth-century art presents a special kind of disorder, formed by the imperfect confluence of two discourses: art historical scholarship, mainly produced in universities in Europe and North America; and the uncounted number of reviews, brochures, and pamphlets produced worldwide. That second writing is a kind of wilderness, scattered with ephemeral exhibition catalogs and brief notices in local newspapers and haunted by the nearly invisible but increasingly oppressive presence of tens of thousands of artists' Web sites. The first kind of writing is concentrated on the principal artists in North America and western Europe; the second includes artists around the world, as well as minor, commercial, and regional artists within Europe and North America. It is a signal fact of the historiography of twentieth-century art that many countries are primarily represented by the second kind of literature: countries such as Paraguay, Cambodia, Macau, Egypt, and Uzbekistan have no tradition of university scholarship in art

history, and the history of their modernist art exists only in art criticism. (Or to say it the other way around: for much of the world, journalistic art criticism is art history.)

Given the outlandish proliferation of texts of both kinds, and their many hybrids inside and outside the university, it might be a reasonable assumption that there are any number of theories regarding which works, artists, concepts, and moments matter most. So it seems. But I have found surprisingly few accounts of twentieth-century art that do not reduce to several basic models. There are, first of all, the strains of modernism: some that still retain the flavor of anarchist or socialist hopes, others gnawed at by capitalist doubts, still others antipolitical or apparently apolitical. Against them, often, are the species of postmodern resistance or expansion: some generous and inclusive, others revisionist. The art historical literature is mainly informed by different instances of that particular disagreement. Outside of academic writing there are several more accounts of twentieth-century painting: one that is prevalent in newspapers and magazines has it that manual skill is the primary criterion for good painting, and another, just as widely disseminated in the mass media, depends on the assumption that painting, like all art, should have a moral or ethical purpose. Those two theories lead to very different senses of twentieth-century painting than either modernist or postmodernist arguments.

There are few competitors to those four approaches and their variants, and that is one of the mysteries of the current

state of writing on twentieth-century painting. Why shouldn't such a contested field generate more accounts of the shape of the century's achievements? Given the animus that was provoked in particular by Clement Greenberg's version of high modernism, and later by postmodern writing in and around the journal *October*, why haven't there been more efforts to come up with workable alternatives? Why hasn't the cumulative work of art historians, critics, and gallerists given rise to a proliferation of theories?

What I have in mind here is a preliminary accounting of these four major strategies for accounting for modern art: modernisms, postmodernisms, the valorization of skill, and the stress on politics. I am not contemplating a history, because that would require a book many times this size, and at least initially I am not thinking of a critical approach, because that would make it difficult to set out the basic claims. History and criticism have their places, but it seems to me there is so little writing that steps back and looks at differing versions of the century as a whole that it is important just to outline the salient approaches and make their differences as clear as possible. At the same time I have not tried to write an account that is wholly disengaged from the issues at hand. The accounts I give here are partial and occasionally partisan, because this text is also intended as a sounding board for further discussion.

Art historians and critics are normally preoccupied with the work at hand, and there is little writing on larger

questions. The exercise I have in mind involves changing the ordinary focus of day-to-day research to ask about the indispensable moments and works of twentieth-century art. What objects and ideas should count as essential? Which are overrated, mistakenly privileged, or otherwise marginal? I am interested in the principal answers that have been given to such questions, because they illuminate the theories that drive judgments of quality and judgments against quality. (And, in the inevitable sequel, judgments against judgment.) My double subject here is therefore the theories and the strange fact that there are so few of them.

A word, before I begin, about the odd word theory. There are theories of art: Panofsky had one, although he did not follow it when he wrote; Heinrich Wölfflin had one; even Bernard Berenson had one. There have been theories of Lacanian psychoanalysis in art; of Peircean semiotics; of Russian formalism; of deconstruction, reception theory, narratology, and many others. Such theories are intended, broadly speaking, to organize historical research, help direct interpretation, and provide criteria for the assessment of art historical knowledge. The changeable sum of theories has constituted a common concern of the discipline since the 1960s, and it constitutes a traditionally contentious definition of the discipline. Theory, in that strong sense, is not quite all of what I want to capture here. When I introduced the word in the second paragraph, I quickly substituted accounts, models, strains, and species. The word in my title is narratives.

By slipping from one word to another I do not mean to elide the problem of fixing what it is I am trying to describe. Rather it is a matter of allowing the named theories into this text when they are relevant but not needing to depend on them when the practices I am concerned with are more diffuse or ill-defined. Much of art writing has precious little to do with anything as formative or ambitious as theories. Art criticism can be structured more by whims, stances, proclivities, and other ephemeral choices, and art history can be written by scholars deeply absorbed in their material and incognizant of any structuring principles that might be given names.[1] The notion here is to capture the widest possible range of ideas about the shape of twentieth-century art. Some of those are theories, and others are better described in other ways. The crucial feature of each is that it is a kind of talking, or a way of writing, that gives the century's art a shape, an overall structure, a form.

This criterion, too, might seem strange. I am aware that by concentrating on writing that has changed the way the century appears to have been structured, I might be taken to be opening a discussion about exactly those theories I have just named. What, after all, has changed the way historians and critics think about the past more than gender studies, identity theory, or the several strains

1. The difference between stands, positions, and stances in art criticism is a subject of my *What Happened to Art Criticism?* (Chicago: Prickly Paradigm Press [distributed by University of Chicago Press], 2003). The absorptive side of art history is a subject of my *Our Beautiful, Dry, and Distant Texts: Art History as Writing* (New York: Routledge, 2000).

of feminism? Who has made a deeper impression on the very idea of historical writing than such theorists as Barthes, Foucault, Derrida, and Lacan? Theories, so it seems, must be at the heart of any inquiry that proposes to sort out the principal perspectives on the modernist past. If I omit theories in this account it is not from a sense that they are dispensable to the project of art history: the exact opposite is the case, and I doubt art history would be a recognizable, or even a very interesting, enterprise without these and other theories. But I find that theories have had, in the end, remarkably little effect on what I am calling the shape of the century: its main movements and isms; its indispensable artists, works, and moments; and even its guiding concepts and what used to be called ruling metaphors.

I cannot defend this approach at length in this context, but here are the main reasons I think that theories have had little effect on received models of twentieth-century art. First, theories have contributed many readings of individual works but have not yet been used to rethink the relative places of entire movements and schools. Semiotics, for example, has helped several generations of art historians rethink their objects, but it has not shifted the roster of artists who receive the preponderance of scholarly attention, or affected the list of movements and styles that continue to articulate modernism at the college and professional levels, or even altered the balance of North American and European interests in postwar art. Feminisms, literary theories, and psychoanalysis have led historians to look at any number of

previously ignored or marginal artists and artworks, but so far at least those new works have only adjusted, and not replaced, the canons of art history.[2]

Second, theories have not yet had measurable effects on the development of newer college-level textbooks. That is important because entry-level texts anticipate college-level pedagogy, which in turn guide students' interests as they go on to graduate study and professional-level work. It matters that theories do not play a part in introductory texts, and it is a good sign that new configurations of undergraduate curricula, and new fields such as visual studies, tend to mix expositions of theory with introductory historical material. At the same time it is important not to be sanguine about the apparently rapid development of the discipline of art history. One of my reasons for writing this book is to point to the ongoing importance of the broadest and, in some senses, least interesting models of twentieth-century art. They are the unnoticed foundation of our more alluring projects.[3]

In a longer format, I would argue that theories have affected the interpretation of art, but not enough of the art that is chosen, for interpretation to make a difference in the principal narratives of the century. Theories have had an effect at an

2. This argument is continued and expanded in my *Stories of Art* (New York: Routledge, 2002), 120–23. On canons see my "Canon and Globalization in Art History," in *Canons in Art History*, ed. Anna Brzyski (Durham, NC: Duke University Press, forthcoming). I thank Ian Patterson for his comments on this point.

3. For these two reasons this argument is different from the one set out in W.J.T. Mitchell, ed., *Against Theory: Literary Studies and the New Pragmatism*, (Chicago: University of Chicago Press, 1985).

entirely different level from the slow winnowing and settling of judgments concerning major movements and periods. The named theories, as they might be called, are a different kind of object than the one I am pursuing here: they will appear in this book but in mixed and fitful ways.

1. Modernisms

In keeping with the synoptic, preliminary nature of this inquiry, I approach the question of modernism by listing several variants, without at first considering how they might be compared. Before I do so, it is relevant to remark that the variety of ways scholars have construed the history and characteristics of modernism is measurably different from the way that other periods in art history, say Baroque or Byzantine, have been understood. If I were to name a Renaissance painting — say Titian's *Diana Discovering the Pregnancy of Callisto* in Edinburgh — and ask about its place in the history of sixteenth-century painting, I might be able to entertain half a dozen different possibilities (see Figure 1.1). In the first place, Titian's painting could be used to exemplify some traits of the Renaissance in general, such as the interest in istoria, or the use of painting as a vehicle for moralizing emblems. More specifically, the painting could be proposed as a characteristic middle period work in Titian's oeuvre. Or it could be seen as evidence of Titian's interest in what has come to be known as Mannerism. It would also be possible to see this painting as a

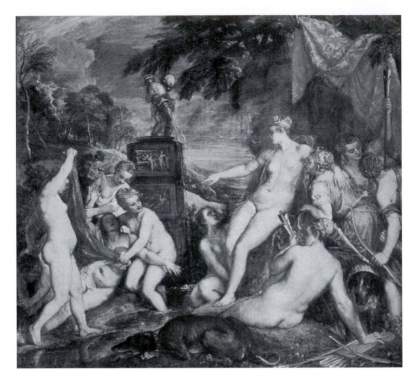

Figure 1.1

representative of the kind of Northern Italian work that Vasari contrasted with good Central Italian practice, and that would tie it to the discourse of colorito and disegno. At a stretch I might define the painting against one of several senses of transalpine art, as an Italian alternative to the practices described, for example, by Karel Van Mander.

This might seem like a wide range of choices, but in fact they are not so much choices as alternate and compatible models, well discussed in the literature and not in conflict with one another.

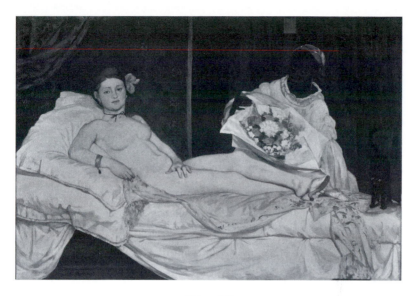

Figure 1.2

I could easily have chosen a Renaissance painting that does not even call up this many different readings. What I mean to point out here is that the historiographic issues for Renaissance painting are settled in a way that those for modernism are not. The working dates for the inception and effective ending of the disegno-colorito debate are well known, and so is the history of the idea that Titian had a Mannerist phase. Most of the interpretations are not the subjects of active discussion, and scholarship has turned to other kinds of questions.

Contrast that situation with a modernist painting, say Manet's *Olympia* (see Figure 1.2). Just mentioning it conjures a whole series of questions whose answers depend on widely different ways of construing modernism and modernist painting. Manet

has been seen as a modernist in at least three very different senses, which I will enumerate later, and, just as significant, historians whose sense of modernism depends on yet other models have bypassed his work, and this painting in particular, as crucial moments in modernism. Modernism, I think, is contested in a way that Renaissance painting is not, and in particular, the alternate theories are not so much aspects of a coherent whole as pieces of different pictures.

It could be urged that new scholarship on Titian has created a set of interests as diverse as the ones that surround the *Olympia.* In the past twenty years historians have uncovered information about Titian's circle of friends and made connections to the sexual life of Venice, and we now know more about Titian's patrons and their political interests. But I do not think these interpretations amount to the divergence of interpretations that surround Manet. It could even be said that the late Renaissance is at stake in what Titian did around mid-century, simply because Titian is one of the principal artists of the period, but there is not, as far as I am aware, an active interest in formulating what "late Renaissance" might mean in this context. It is not a conceptual category that requires attention in the way that modernism does. In regard to Manet, by contrast, everything is at stake: he is a fulcrum of the modernist sensibility in painting, and that matters because it directly affects, or even determines, what counts

as twentieth-century modernism and even what counts as con-
temporary practice.

Let me illustrate the difference with an example from con-
temporary academic politics. In the English and Irish univer-
sity systems, there is a position known as an external assessor,
which is a person engaged by a department to comment on the
examination questions before they are given, and also to read and
help grade the students' answers to those questions. Part of an
external assessor's job is to ensure that the examination questions
proposed by the department's lecturers are well posed and set at
the appropriate levels. Now when I first heard about that system,
I was astonished. It seemed amazing that someone in another
university could be trusted to understand what might be hap-
pening in classes I was teaching. After I learned more about the
system, I began to see its strong points — among other things, it
reveals inadequately prepared classes — but I also came to think
that it fits premodern art history much better than modernism
or postmodernism, because the large-scale historiographic issues
are widely agreed on in Renaissance and other premodern art.
If an instructor chooses to emphasize gender or patronage, it
is understood that those issues lie in some measure to one side
of the kinds of judgments that give the works their places in
the traditions in question. Sexual practices in sixteenth-century
Venice could be used as a way to introduce *Diana Discovering*

the Pregnancy of Callisto, but questions of gender and sexuality would be understood to be at once independent of, and compatible with, existing narratives about Mannerism and northern Italian painting.

With modernism things are different. It is conceivable that a modernist in one university may wish to teach in accord with theories of high modernism and that the external assessor might subscribe to differing accounts. In that case, the external assessor would have to find the examination questions to be biased or effectively empty; the assessor would, if he or she decided to push the issue, be compelled to say that the entire content of the course in question requires rethinking. In the case of Manet's *Olympia,* for example, an assessor with an interest in postmodernism might find an account based on Manet's formal innovations to be more than merely incomplete; it might appear misguided because it omits the image's political and gender content. The theories are too strongly at odds to be posed as compatible alternates.

This example is the clearest way I know to introduce a fundamental property of the accounts I will be considering; each constitutes a choice that implies very different objects, artists, and movements, and strongly affects what is taken to be worth saying about a given painting, period, or problem.

It would be possible to employ any number of criteria to order and collate the theories of modernism. Theories of modernism could be distinguished, for example, by writing their

histories. Such a strictly historiographic approach would make it possible to locate the genealogies of current ideas; Jürgen Habermas's critique of modernity, for instance, could be traced back to German romanticism. The drawback of a historiographic approach is that the order in which the theories appeared does not correlate with their interest for art history in the twenty-first century. To understand currently viable models of twentieth-century painting, it is not always relevant to know that a given approach began before or after another one. It would also be possible to arrange theories of modernism according to other criteria, for example, their politics, the biographies and institutions of the historians who proposed them, the effect they had on the market, their endorsement by major museums, or their degree of attachment to the disciplines of art history or philosophy. Here I am choosing a simple diagnostic criterion: the works and years that have been taken to be the inception of modernism, in particular in painting. That criterion has the double advantage of being relatively amenable to exposition in a brief format and also applicable to the question at hand — an inventory of the currently viable senses of the past century. Looking at the proposed starting points of modernism results, I think, in five distinct senses of modernist painting.

Before I list them, it is worth noting that I use the terms theories, strategies, and models to describe these accounts, even though few of them were proposed as such. They

normally appeared in monographs on particular subjects, not in theoretical tracts about the concept of modernism in painting. Calling them theories posits differences between these texts that are as clear as they would be if the texts had been theories in the philosophic sense. The distortion, I hope, pays dividends in clarity even though it necessarily misrepresents implicit positions as argued ones.

It is also significant that these theories are rarely listed or even named, even though the differences between them are ingrained in current writing in art history. There are various reasons for that lacuna in the scholarship, which need to be inspected more closely than I can do here. One possible reason is a disciplinary resistance to large-scale theories; there is an understandable reticence, for example, about expanding beyond the limits of the individual works or artists under study. That is not just a matter of custom; it points to the structure of the discipline, which can be inimical to explicit conceptual exchanges outside of historically determined settings. That in turn means that the questions I am setting out here run against the grain of some current work in art history in ways that I will not be able to mend. The lacuna is also due to the common and reasonable conviction on the part of art historians that all true theories must coexist in the end, because they describe perspectives on the same material. That pluralist stance is one that

I think needs to be regarded with extreme skepticism. As I will try to make clear, these five theories of the origins of modernism are often mutually contradictory.

1. Modernism Begins in the Renaissance

Proceeding chronologically, the High Renaissance is the first period that has been proposed as the beginning of modernism in painting. (I will be using the expressions modernism in painting and modernist painting interchangeably. Both are distinct from modern painting, which begs the questions I am asking here by proposing that the moment of "the modern" is known.) Several texts could be proposed as *loci classici*. Jakob Burckhardt's *Civilization of the Renaissance in Italy* would be one, in that it proposes the High Renaissance as the inception of visual culture and individuality — a combination of emphases that resonates with the current interest in popular visual culture or visual studies. A very different text that also could be read in support of the claim that modernist painting began in the Renaissance is E.H. Gombrich's "The Leaven of Criticism in Renaissance Art: Texts and Episodes." Gombrich proposed a formidable array of concepts that could be understood as modernist; first, that "an acceptance of the Renaissance conception of art implied an acceptance of the notion of progress," thus launching the idea that art must change through time, an idea that is at the center of

twentieth-century notions of the avant-garde.[1] Then there was the inception of a "critical milieu" and the notion of the *dimostrazione* (show of skill) that together made art criticism possible. Gombrich also mentioned the idea that artistic ideals could be multiple and contemporaneous; a notion that is itself a distant but indispensable origin of current ideas of artistic pluralism. He emphasized Vasari's ambition to "write history rather than a mere chronicle," thus hinting that art history began in the Renaissance.[2] And he noted that in some circles "the display of virtuosity as such … gained priority over the subject matter," a key modernist concept in each of the theories I will be considering.[3]

Gombrich did not say that modernism as such began in the Renaissance, and at the close of the essay he mentioned two properties of modern art — not modernism — that the Renaissance lacked: it never formulated … the crucial experience that for every problem solved, a new one could be created," and it was not sensible of the fact that the inception of new visual practices such as "the mastery of perspective and the nude" had obscured and even "destroyed" parts of the medieval tradition. That sense of loss, together with the feeling that "problems" in art are unending and linked one to the next, are — so Gombrich implied, without quite saying as much — important elements of

1. E.H. Gombrich, "The Leaven of Criticism," in *The Heritage of Apelles: Studies in the Art of the Renaissance* (Ithaca, NY: Cornell University Press, 1976), 111–31, quotation on p. 115.
2. Ibid., 115, 116, 120, 128.
3. Ibid., 129.

modernism. If he had been writing directly about modernism, he would have had to say that "sciences" such as "perspective and the nude" were exactly the ones cast in doubt by modernist practices.

Even given those caveats, Gombrich's essay is the most compact inventory of reasons why the Italian Renaissance might be thought of as the moment when modernism began. At its most interesting, the discourse of Renaissance painting, as Gombrich described it, was historically aware, critically engaged, cognizant of pluralism, and invested in self-referential works that were seen to be in dialogue with one another: all common elements of modernism in visual art.

Whether it seems relevant to look back as far as the Renaissance to understand modernist painting is another matter. In general, the discipline of art history has not thought so. Erwin Panofsky entertained the possibility, which he called the "expanded Renaissance." And there have been a few scholars who have written about modernist concepts in Renaissance works, but for the most part, the Renaissance has been understood as a precedent and source for modernism rather than a direct origin of modernism.[4]

I am tempted, again, to recast the idea that the Italian Renaissance is a model or precedent rather than an origin, as a matter of disciplinary customs and preferences. There is some

4. For the "expanded Renaissance," see Erwin Panofsky, *Renaissance and Renascences in Western Art* (New York: Icon, 1972).

evidence, mostly anecdotal, that art historians who specialize in the Renaissance tend to picture the period as a kind of foundation for later art history and, in a general sense, for the discipline as a whole. From that perspective Renaissance painting can be understood as an origin for modernist painting and not only an antecedent. This is not often said in so many words, but it becomes visible in several ways. At art history conferences Renaissance sessions tend, on average, to be more serious than sessions on modern or postmodern art. The level of scholarship and the ambition of the papers might be comparable in the different specialties, but it is more common to find that Renaissance sessions are infused with a seriousness of purpose and an interest in cultural immersion in a way that sessions on contemporary art sometimes are not. That, of course, is entirely unverifiable; I offer it as my own experience. A little more verifiable is the fact that Renaissance scholars tend to be involved, to different degrees, in contemporary art, whereas art historians who specialize in modern or contemporary art tend not to follow developments in Renaissance scholarship. It would be possible to quantify that impression by counting the citations of Renaissance scholarship in papers on recent painting and comparing them to mentions of contemporary art in Renaissance scholarship.

I hazard these opinions because they point to a deep structure within art history: a disconnection between Renaissance and modern scholarship. Texts such as Gombrich's that propose

connections between modernism and the Renaissance are in a tiny minority. Despite the very cogent arguments in favor of situating at least some elements of modernist painting in the sixteenth century, it is the least accepted of the five theories I am reviewing. The reasons for the lack of acceptance are elusive, because there is not yet a sustained conversation on the subject. One reason might be that the current configuration of the discipline of art history does not provide venues for texts that bridge the two periods. Another answer could be that whatever counts as modernism in painting has more to do with the assault on naturalism than is sometimes countenanced; a third possibility is that modernism requires the rise of the bourgeoisie and the political configurations that followed the French Revolution, thus rendering the Renaissance intermittently irrelevant.

2. Modernism Begins at the End of the Eighteenth Century

That last reason for distinguishing Renaissance painting from modernist painting also serves to justify the idea that modernist painting was first practiced toward the end of the eighteenth century — whether the exact starting point is identified with the Industrial Revolution, the French Revolution and the emergence of the middle class, the rise of romanticism, the developments in French painting in the generation of Diderot, the school of David, or even the "International Style" around 1800. Here the

historiography begins to become quite complicated, and I will confine myself to four arguments that place the origin of modernism toward the end of the eighteenth century.

The most carefully worked out model is Michael Fried's. His account of what he calls the "antitheatrical" tradition in French painting and criticism beginning in the generation of Diderot has been developed during the past twenty-five years in a number of books, preeminently *Absorption and Theatricality: Painting and the Beholder in the Age of Diderot.* Fried has provided several introductions to the thematic in other books, so I do not repeat that material here.[5] The claims in *Absorption and Theatricality* are not intended as markers of pictorial modernism as such, and the book does not present itself as an account of modernism's origins. Even so, *Absorption and Theatricality* is one of the most tightly reasoned accounts of a formative difference — a turn, a twist in the sequence of historical understanding as Fried has said in another context[6] — that put painting on a new course beginning in the 1760s. In the final paragraph of the introduction to *Absorption and Theatricality*, Fried posited

5. Michael Fried, *Absorption and Theatricality: Painting and the Beholder in the Age of Diderot* (Berkeley: University of California Press, 1980); and see Michael Fried, *Courbet's Realism* (Chicago: University of Chicago Press, 1992), especially pp. 6–20.

6. Michael Fried, "An Introduction to My Art Criticism," in *Art and Objecthood* (Chicago: University of Chicago Press, 1998), 52. The trope is used in an interesting and crucial passage in which Fried distinguishes his art historical writing from his art criticism. In the course of that discussion he observes, "It's as if somewhere around 1960 time undergoes a twist, and as if this side of that twist my relation to that issue [of theatricality] remains implacably critical, not historical."

a link between his own writing on art of the 1960s and his scholarship on French painting of the late eighteenth century and concluded, "This book may be understood to have something to say about the eighteenth-century beginnings of the tradition of making and seeing out of which has come the most ambitious and exalted art of our time."[7] It is therefore not reading against the grain of *Absorption and Theatricality* to take it as an account of the conditions that continued to inform important painting for the next 200 years.

If the problematic Fried explored in *Absorption and Theatricality* is understood as constitutive of modernism, then modernism becomes a set of problems posed by painting, among them the limitation of painting that expressly addresses its viewer; the strategies for retrieving a kind of viewing that Fried calls "absorptive"; and the differing balances that have had to be struck, at different times since the 1760s, between painting that fails by giving in too easily to the theatrical staging of viewer and viewed and painting that fails by choosing anachronistic, simplified, or otherwise ineffectual strategies for resisting that theatricality. Painting becomes a contested discursive field whose critical terms are given by the contemporary criticism and by the phenomenology of seeing. It would not be accurate to say that Fried's sense of the late eighteenth century or of the

7. Fried, *Absorption and Theatricality*, 5.

thematic of antitheatricality have become commonly accepted models in art history. They are universally cited, in art history and criticism, but seldom engaged. Taken as a model of modernism in painting, Fried's thematic has the interesting property of being at once significantly different from some others — ones I will mention in a moment — and also potentially an explanation for those same models: a point that has not often been registered in the discipline.[8]

A second model that locates the first modernist painting at the close of the eighteenth century is set out in the first chapter of T.J. Clark's *Farewell to an Idea: Episodes from a History of Modernism*.[9] The argument is that David's *Death of Marat* is the "inaugural" modernist painting because after it, painting was "forced to include the accident and tendentiousness of politics in its picture of the world — not just in the things it shows, but in its conception of what showing now is" (see Figure 1.3). The result was a painting that "enacts the contingency of claims to truth and falsehood at the moment it was made."[10] At first it appears that a necessary part of that enactment would be that painting acknowledge its immanent entanglement with the conditions at hand, and therefore with the impossibility of transcendence. But

8. The leading exception is Stephen Melville, *Philosophy beside Itself: On Deconstruction and Modernism* (Minneapolis: University of Minnesota Press, 1986).
9. T.J. Clark, *Farewell to an Idea: Episodes from a History of Modernism* (New Haven, CT: Yale University Press, 1999).
10. Ibid., 38, 43, respectively.

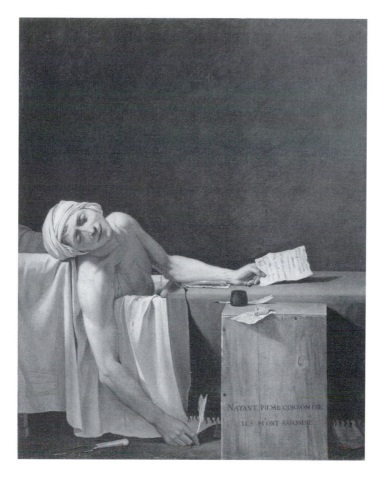

Figure 1.3

— in characteristic fashion — as soon as Clark said "modernism turns on the impossibility of transcendence," he qualified it in an exact and tortured fashion. Because "modernism is Art," he wrote, and because "Art ... is exactly the site ... on which the impossibility of transcendence can be denied," it must also be that modernism "is a process that deeply misrecognizes its own

nature for much of the time." Modernism's enemies think that its "brokenness and ruthlessness" are "willed, forced, and ultimately futile," so that transcendence can still happen under cover of the supposed ruins of culture. On the other hand, modernism's "false friends" say that its insistence on destruction, impossibility, and "extremity" are just the "surface appearance," which serves to protect wholeness and transcendence. Hence modernist painting has to misrecognize itself, misinterpret its own strategies, and misidentify its own embrace of contingency.[11] That is true throughout modernism, which Clark described as being built on the struggle to come to terms with its own repressions and fictions. At the time of the *Marat*, art was not ready "to understand its place in the disenchantment of the world," but that remained true throughout modernism: in fact "the whole history of modernism could be written in terms of its coming, painfully, to such an understanding."[12]

Clark's account has been faulted for its sometimes peculiar readings: for example, the notion that the empty space above Marat conjures the "endless, meaningless objectivity produced by paint" and the signal fact that for modernism, technique "is a kind of shame"; or the allied claim that the partly illegible handwriting on Charlotte Corday's note enacts the limits of painting.[13] I do not think the reviews have properly located

11. Ibid., 22.
12. Ibid., 34.

the principal point, the one that required those elaborations, in essence that the most successful painting after David is a continuous reimagining of the conditions of painting, impelled by the realization that two apparently disparate things have to be linked: the uselessness of the received rules of painting and the hopelessness of proceeding as if painting could be the place where the world is "reenchanted."

The third model that places modernism at the end of the eighteenth century is much simpler than Clark's or Fried's; it is Robert Rosenblum's idea that neoclassicism struck a kind of bedrock in the generation around 1800, forcing a reappraisal of painting. Rosenblum's doctoral dissertation was on that subject, and so were several early books, including *Transformations in Late Eighteenth-Century Art*.[14] The dissertation, published in 1976 as *The International Style of 1800: A Study in Linear Abstraction*, makes the claim most clearly: according to Rosenblum, painters in Ingres's studio, especially those around Maurice Quaï who called themselves *Les primitifs*,

13. Ibid., 48. There are many largely off-target reviews. The most aggressive and interesting is Karl Werckmeister, "A Critique of T.J. Clark's *Farewell to an Idea*," *Critical Inquiry* 28 (2002): 855–67. I find less of value in Charles Altieri, "Can Modernism Have a Future?" *Modernism/Modernity* 7, no. 1 (2000): 127–43; Gail Day, "Persisting and Mediating: T.J. Clark and 'the Pain of "the Unattainable Beyond," ' " *Art History* 23, no. 1 (2000): 1–18, although it offers a clear set of problems for social art history; David Joselit, "Contingency Plan," *Artforum* 37, no. 9 (May 1999): 21–22; Stephen Eisenman, "Modernism's Wake," *Art in America* 87, no. 10 (1999): 59–61; and Robert Herbert, "Goodbye to All That," *New York Review of Books* 46, no. 17 (November 4, 1999): 28–31. Jay Bernstein's review is mentioned later.

14. Robert Rosenblum, *Transformations in Late Eighteenth-Century Art* (Princeton, NJ: Princeton University Press, 1967).

created a style unlike any previous one.[15] The "dream of the tabula rasa," Rosenblum concluded, "has never ceased to haunt and to nourish the imagination of artists working in the modern world."[16] This is not the same as saying that modernism began in 1800, and *Transformations in Late Eighteenth Century Art* is presented as a revisionary account of neoclassicism and the origins of romanticism and not as a theory of modernism. But it is clear that for Rosenblum the years around 1800 are understood as a fulcrum of Western painting. Rosenblum is one of the authors whose works can be surveyed for references to Renaissance painting; there are few, and that alone is enough to suggest that books such as *Transformations* are, in effect, accounts of the origins of modernism.

Properly speaking, Clement Greenberg also belongs in the list of writers who locate modernism's inaugural moments around the end of the eighteenth century, with the spread of the Industrial Revolution and the appearance of the bourgeoisie. The Enlightenment gave rise to modernist painting, in Greenberg's account, by instituting the concept of self-critique. His idea that Kant is "the first real modernist" is meant to provide a genealogy for the self-awareness of modernist painting, which is able "to criticize the means itself of self-criticism," to "use logic to establish the limits of logic."[17] This self-critique is the motivation

15. Robert Rosenblum, *The International Style of 1800: A Study in Linear Abstraction* (New York: Garland, 1976). See also Rosenblum, *Transformations*, 183–85.
16. Rosenblum, *Transformations*, 191.

for modernist painting's rejection of "realistic, naturalistic art," which had "dissembled the medium, using art to conceal art."

Greenberg's sense of the history of modernism is not specific to the period around 1800, and in "Modernist Painting" he mentions David, Manet, the impressionists, and Cézanne in succession, but the putative origins of modernism are in the political, philosophic, and social conditions of art in the late eighteenth century. It is telling, for example, that David is imagined as reacting against Fragonard; the time frame is clear, even given that the opposition is rhetorical, and that "Fragonard" is an emblem for painting that remained in thrall of naturalism.[18] I will have more to say about Greenberg later, because he associated the crux of modernism — and therefore, in another sense, an origin of modernism — with abstract expressionism.

The four accounts I have chosen to represent the idea that modernism began around 1800 — Fried's, Clark's, Rosenblum's, and Greenberg's — could be augmented by many others. Barbara Stafford, for example, has written about modernist qualities in what she called "ideographic" art of the seventeenth and eighteenth centuries.[19] "It was precisely in the eighteenth

17. Clement Greenberg, "Modernist Painting" (1960), in *Clement Greenberg: The Collected Essays and Criticism*, vol. 4 of *Modernism with a Vengeance, 1957–1969*, ed. John O'Brian (Chicago: University of Chicago Press, 1993), 85–93, quotation on p. 85.
18. Ibid., 86–88.
19. The earliest is Barbara Stafford, *Symbol and Myth: Humbert de Superville's Essay on Absolute Signs in Art* (Cranbury, NJ: University of Delaware Press, 1979), which is reworked from her dissertation (1972).

century," she wrote, "that the persisting rationalist philosophical attitude toward images hardened into systems," opening the way to the visuality typical of modernism and postmodernism.[20] Horst Bredekamp, another specialist in those centuries, has written about modernist visuality in Leibniz, Hobbes, and early scientific illustration.[21]

This open-ended list provides an occasion to develop the problem of the incompatibility of such theories. On one hand these theories could all be considered as perspectives on the same material, and therefore potentially equally true. In particular these four or six theories about the late-eighteenth-century origins of modernist painting are in rough agreement about modernism's *terminus post quem*, and they depend on many of the same painters. The same could not be said for some of the theories I will discuss next, and so it might seem reasonable to say that these are compatible alternatives and that others I will come to in a moment are different. On the other hand there are good reasons to consider even these four or six theories as rivals whose relations are still undecided.

In *Absorption and Theatricality*, Fried said that attempts to explain eighteenth-century French painting by appealing to the "social, economic, and political reality of the age" are "misconceived." His own account, he said, "is intended at once

20. Barbara Stafford, *Good Looking: Essays on the Virtue of Images* (Cambridge, MA: MIT Press, 1997), 22.
21. For example, Horst Bredekamp, *Thomas Hobbes, Visuelle Strategien: Der Leviathan, Urbild des modernen Staates* (Berlin: Akademie, 1999).

to repudiate prevailing social interpretations of the subject and to dissolve various confusions to which those interpretations have given rise." Social art history is one target of Fried's interpretation, and historians — such as Rosenblum — who rely on periods are another. Fried proposed to replace the usual sequence of "Neoclassicism, Romanticism, Realism, etc." with "a single, self-renewing, in important respects dialectical undertaking."[22] These objections are not raised against named scholars, but they show the limits of compatibility between Fried's account and the others I have mentioned. The same has to hold, logically speaking, for their compatibility with Fried's account. I imagine that in a world freed of friendships and academic obligations, talk about the incompatibility of these models would turn on the claim, implicit in each, that it holds interpretive power over the others. The metamodel for these models would then be something like Einstein's encompassing of Newton's theories, or João Magueijo and Andreas Albrecht's encompassing of Einstein's theories. The rivals are not wrong, but their models would be seen as incomplete or restricted.[23] In the current state of the discipline, those discussions have not taken place, and the result can be a misleading sense of perspectivism: that each theory seems to be a partial account, compatible at root with the others.

22. Fried, *Absorption and Theatricality*, 4.
23. Just for curiosity's sake: Magueijo and Albrecht, "A Time Varying Speed of Light as a Solution to Cosmological Puzzles," http://eprints.lanl.gov/ (accessed March 8, 2005), astro-physics paper 9811018.

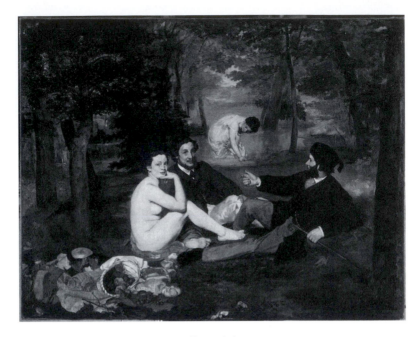

Figure 1.4

3. Modernism Begins in the Generation of
Manet and Baudelaire

It is again Fried who has made the most elaborate defense of
Manet as the inaugural modernist painter (see Figure 1.4). His
three-part argument, which I do not summarize here, includes
the idea that Manet wanted to establish "the universality of
his painting with respect to the major national schools," and
that he did so in part by quotations and references to the
history of painting.[24] The sense that painting after Manet

24. Fried, *Manet's Modernism: Or, the Face of Painting in the 1860s* (Chicago: University of
 Chicago Press, 1996), 403. The tripartite argument is summarized on pp. 399–413.

became newly dependent on references to its own history is a different kind of claim than those I have mentioned so far. It is also different from literary-critical discussions of modernism, which often begin in the generation of Manet and Baudelaire, but then diverge from visual art. Some literary histories of modernism start with Baudelaire's "Painter of Modern Life" and especially his claims for the importance of "the representation of the present," which is a theme that is well developed in the art historical literature. But literary histories then continue on through Zola, symbolism, and Anglo-American literary modernism — Yeats, Woolf, Lewis, Joyce, Eliot, Pound, and Lawrence.[25] There are other reasons to consider Manet's generation as the starting point of pictorial modernism aside from painting's new subject matter and its new sense of dependence on its own history. I will name several others later; it appears that this point of origin might be the most heterogeneous of all.[26]

4. Modernism Begins with Cézanne or Picasso

The claim that Cézanne and Picasso (or, more broadly, post-impressionism and cubism, respectively) are the foundation of

25. For example, in John Gross, ed., *The Modern Movement: A TLS Companion* (Chicago: University of Chicago Press, 1992), which includes no visual art. An exception is the partly visual, partly literary trajectory of Peter Nicholls's *Modernisms: A Literary Guide* (Berkeley: University of California Press, 1995), which begins with "The Painter of Modern Life" (p. 5) and continues with decadent art, Mallarmé, futurism, expressionism, Dada, and neoclassicism.

26. An observation made by Fried, *Manet's Modernism*, 13.

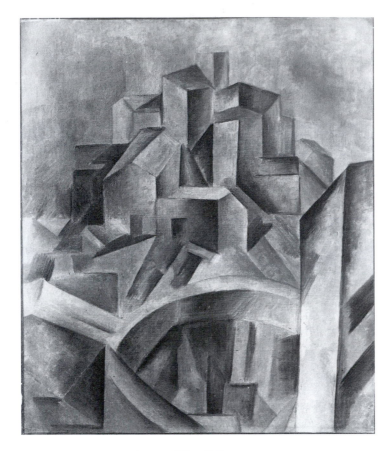

Figure 1.5

modernism in painting depends on the notion that they worked to dismantle coherent perspectival space (see Figure 1.5). The claim is debatable when it takes its more radical forms — that space was destroyed, overturned, or abandoned, rather than modified.[27] The theory, first disseminated by critics such as Roger

27. I argue against the notion that pictorial space was overturned by modernism in my *Poetics of Perspective* (Ithaca, NY: Cornell University Press, 1994), 259–60.

Fry, is popular in undergraduate textbooks as a convenient way to introduce twentieth-century painting. Curiously, even though this account is the one most often repeated in first-year college textbooks, it is the least theorized, and the versions I have seen are not in accord with Fry's insistence on the continuity between modern and premodern pictorial composition.[28] Indeed it is not clear to me that Cézanne's or Picasso's alleged destruction of pictorial space, regardless of the truth of the claim, is a concept that organizes much of current thinking about twentieth-century painting or modernism. Even in Greenberg's account, what matters is not the specific strategies that can be deduced from canvases by Picasso or Cézanne but the increases in painting's reflexiveness or self-referentiality, and concomitantly its capacity for self-critique.

The origin of modernism in the destruction of rational perspectival space is an orphaned concept, crucial to introductory pedagogy but disconnected from the discipline's concerns. (It resurfaces in the theory of modernism as skill, which I will consider later.) The problem, therefore, in accounts of modernism that depend on the destruction of rational fictive space is how the alleged destruction tallies with the many other ways of conceiving modernism.

28. For example, H.H. Arnason's *History of Modern Art: Painting, Sculpture, Architecture, Photography*, 3rd ed. (New York: Prentice Hall, 1986), considers various dates as the beginnings of modernism (1863, 1855, 1784) but quickly settles on the theme of "pictorial space" and its gradual dissolution (p. 13).

Figure 1.6

5. Modernism and North American Abstract Expressionism

In contemporary art practice, abstract expressionism and abstraction more generally are common *de facto* starting places for modernist painting, because they provide the putative opposites of current practices (see Figure 1.6). Greenberg's criticism has been read in this way by emphasizing certain texts and artists. Because this is the position most often associated with Greenberg, I will pause a moment to expand on the dissemination of ideas about his writing.

It is important, first, not to assume Greenberg's influence is evenly distributed throughout the world. In the United States and in England, Ireland, Italy, Germany, Scandinavia, and France, he

tends to be considered the most important critic of the second half of the twentieth century, and his influence on the shape of art history is acknowledged if not undisputed. Ph.D. theses are written about him, and he is a recurring subject in seminars and colloquia. At the beginning of the twenty-first century in those countries, painters tend to think of Greenberg as the opposite of whatever sense of painting they are pursuing. Elsewhere in the world — especially, I find, in Spain, Portugal, Italy, central and eastern Europe, Latin America, and China — Greenberg is either marginal or wholly unknown. I have been told that in South Korea he is commonly cited as an example of an art theory that is peculiarly American. In Central and South America there is only one book about Greenberg, edited by the art historian Glória Ferreira; the book also has translations from texts by Fried and Rosalind Krauss.[29] A conference held in Mexico City in fall 2002 was the first colloquium ever held in Mexico on Greenberg; its organizer told me he had trouble convincing people the subject was important, and one critic even expressed doubt that it was worthwhile to convene a conference on any critic. The contributors, who included Laurence Le Bouhellec, Issa Benítez, Yishai Judisman, and David Pagel, had varied opinions about Greenberg's necessity and importance.[30] As far as I can tell, that

29. Personal communication, autumn 2002. I have been unable to trace the book.
30. Thanks to Tania Valenzuela of the Museo Tamayo Arte Contemporáneo for this information (letter, March 3, 2003).

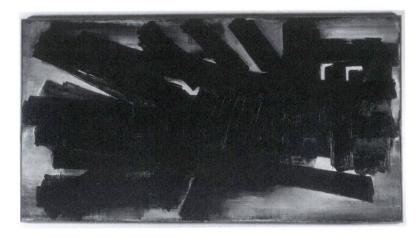

Figure 1.7

forum has faded from memory, and so has Ferreira's book. Much of the world has yet to encounter Greenberg, and there is reason to think that in many places his ideas will never be regarded as important ones.

In North America, on the other hand, Greenberg's modernism is easily the most influential model of modernist painting; it is common for graduate art history students interested in painting after 1945 to study Greenberg, and for painting students to take up and often refute his questions as a way of defining their own practices. Greenberg's choices have also made many painters nearly invisible to Anglo-American scholarship; I do not know any North American critics or historians who have written at length on Jean Fautrier, Simon Hantaï, Philippe Hosiasson, or Pierre Soulages (see Figure 1.7). In my experience American graduate art history students often do not even know about them.

These blindnesses are sustained by a very powerful body of writing, which compels an answer from everyone who encounters it. For the purposes of this argument, I will distinguish four groups of responders to Greenberg's work: those who reject him, those who are interested in his early work, those who follow the later work, and those — the remainder, and therefore the majority of the world — who have never read or heard of him.

I would estimate that the majority of contemporary North American painters take the first option, avoiding Greenberg's work altogether, either by claiming that it is an unhelpful formalism or by taking it as the sign of a reductive practice that disallows other media. In both readings Greenberg is thought to have been interested only in the flatness of the canvas, the shape of the support, and the capacity of abstract paintings to refer to themselves.[31] This misreading bundles three separate misunderstandings together under the name Greenberg: formalism, taken to mean that the painting depends entirely on its materials and not on its context or the artist's intention; self-referentiality, understood as an inflexible criterion of good art; and an antipsychological stress on what is taken to be pure vision and opticality. All three serve as justifications for a range of contemporary practices that are, among other things,

31. The canonical statement, often quoted out of its context (which is, roughly speaking, the argument that in modernism, self-critique led each art to the irreducible conditions of its own medium) is Greenberg, "Modernist Painting," 86.

opposites of those three positions. This is an "elitist" reading, as Clark put it: it is as if "the monster called 'Greenberg' has to be humbled and ridiculed time after time — as if the culture needed reminding how dreadful the idea of 'art' was, before it gave way to that of 'visual culture.' "[32] This first reading of Greenberg can be easily questioned by recourse to the primary texts, but in my experience that has not stopped art students and art history students from a kind of productive "loathing" of Greenberg.[33]

A second reading emphasizes the early writings, especially "Avant-garde and Kitsch" (1939). Despite the fact that more than 300 essays on kitsch appeared between 1884 and 1939, "Avant-garde and Kitsch" is easily the most influential text on the subject.[34] It would be possible to reduce its significance by showing Greenberg's dependence on the earlier literature. It might be interesting to try reviving some of the better earlier essays (especially Hermann Broch's provocative text),[35] but those

32. Charles Reeve, "Art History without Endings: A Conversation with T.J. Clark," *Documents*: 6–18, quotation on p. 10.

33. Loathing is Clark's word, in Reeve, "Art History without Endings," 10. As a balance I have found it useful to read Greenberg's review of *Romantic Painting in America*, ed. James Thrall Soby and Dorothy Miller (New York: Museum of Modern Art, 1943), in *Clement Greenberg: The Collected Essays and Criticism*, vol. 1, *Perceptions and Judgments 1939–1944*, ed. John O'Brian (Chicago: University of Chicago Press, 1988), 172. Romantic painting in America was a major exhibition: it included Eakins's *Gross Clinic* and Church's *Cotopaxi*, though it is hard to guess that from Greenberg's account. On Greenberg's defense see further Thierry de Duve, *Clement Greenberg between the Lines: Including a Previously Unpublished Debate with Clement Greenberg* (Paris: Éditions dis Voir, 1996).

34. See the excellent bibliography by the librarian Hermann Schüling, *Kitsch-bibliographie* (Gießen: Bibliothek, n.d., c. 1975). Another good corrective is Abraham Moles, *Psychologie des Kitsches*, trans. Bernd Lutz [from French] (Munich: Carl Hanser, 1972).

35. Broch's "Notes on the Problem of Kitsch" is available in English in Gillo Dorfles, ed., *Kitsch: The World of Bad Taste* (New York: Universe Books, 1969), 49–76.

exercises would miss the point of Greenberg's influence. For several generations since its reissue in 1961, "Avant-garde and Kitsch" has been the definitive statement about the importance and fragility of the avant-garde.

The core argument is easily summarized. In Greenberg's view mass culture is an ongoing threat to fine art, because it appropriates and dilutes the work of the avant-garde. Serious artists and critics have to be vigilant about the real avant-garde. The economy of art sketched in "Avant-garde and Kitsch" is strictly one-way. Art is produced in conditions of some mystery, apart from the normal class structures of society, and then society consumes the result: not only by appreciating, emulating, and studying it as fine art but also by watering it down so it is palatable to less adventurous tastes, and ultimately bowdlerizing and debasing it. Greenberg defined kitsch several times; according to the first two definitions, kitsch "operates by formulas" and produces "vicarious experience and faked sensations."[36]

"Avant-garde and Kitsch" also insists, famously, that "the avant-garde moves"; once it has produced something new, that thing immediately begins to tarnish in the corrupt air of bourgeois appreciation. The avant-garde artist then has to strike camp and move on. A permanent avant-garde is an impossibility, a self-contradiction. An avant-garde artist has to be continuously

36. Greenberg, "Avant-garde and Kitsch," in *Clement Greenberg: The Collected Essays and Criticism*, vol. 1, 12.

inventive, unpredictable, elusive, nomadic. The avant-garde needs to be the rule that escapes all rules; otherwise its bourgeois pursuers would be onto its game.

Embracing kitsch is arguably no longer a daring thing to do, because kitschy artwork no longer implies a rejection of the avant-garde. In practice, art that appears as kitsch may be understood as work with a particular kind of avant-garde ambition, the idea being to show radicalism by being insouciant about kitsch. Pop art began the flirtation with kitsch, and now art students paint in DayGlo colors, use spray insulation foam, and make collages with commercial linoleum. Jeff Koons's place in the history of twentieth-century art is assured in part because of his apparently deeply sincere endorsement of kitsch ideas and kitsch media. Works such as Koons's might have been less outrageous and annoying if a generation of artists beginning in the early 1960s had not been reading "Avant-garde and Kitsch" (then newly available in book form).

The third reaction to Greenberg turns on his late work, especially the essay "Post-Painterly Abstraction."[37] What matters here is that a thoughtful reading of Greenberg's later writings requires a commitment specifically to painting. In a Greenbergian

37. David Carrier is an example of a writer influenced by this mode of thought, despite his distance from Greenbergian orthodoxy. See, for example, the distanced but very sympathetic account of recent painting by Jules Olitski in Carrier, "New York Abstract Painting and Sculpture," *Burlington Magazine* 137 (January 1995): 52–53; and Carrier, "Afterlight: Exhibiting Abstract Painting in the Era of Its Belatedness," *Arts* 66 (March 1992): 60–61.

view, video, installation art, performance, and other multi-media experiments have to be considered marginal and mis-guided because painting remains the central Western visual art. (Sculpture, which also interested Greenberg, is a close second.) In this reading of Greenberg, artists who do not feel the historical pressure of painting are not experiencing the force of a fully his-torical awareness of twentieth-century art, and those who opt for other media might be doing so to escape the demands of painting. After postpainterly abstraction, it became exceedingly difficult to make a successful painting by the criteria that have been derived from Greenberg's later essays, but the same essays support the idea that painting has not yet run its historical course. In this reading, the questions raised by multimedia art are likely to be ill-formed versions of problems that can best be proposed by painting. An easy way to fail, therefore, is to do something other than paint, or to adulterate painting in facile ways — by bolting a painting to a goat and a tire as Rauschenberg did, or by turning painting into performance as Yves Klein did.

Greenberg's tacit rejection of everything outside some paint-ing and sculpture is irritating for many art students and younger artists. From their perspective Greenberg seems so patently out of touch with what has happened since pop art that he does not deserve to be taken seriously. Here I think it is important to be circumspect. Even though the majority of working artists would not subscribe to the doctrine that painting is the central visual

art, and even though the majority of contemporary painters in North America and Europe would not agree with Greenberg's sense of painting's history, his ideas are still very much at work. His account of modernist painting remains the most powerful model, and ideals such as reflexivity and the generative importance of an avant-garde are insinuated in contemporary criticism even when the subject is installation, video, or performance art.

The fourth reading of Greenberg is the most widespread. Readers who do not know who Greenberg is — who would not recognize his name — can still be influenced by him when they read texts that are influenced by his writing. In my experience the moving-target model of the avant-garde is one of the first observable effects of Greenbergian high modernism in places that have not yet discovered Greenberg's texts. In Hangzhou, China, in 1999, I found Chinese art students trying hard to understand *Artforum*, *Art in America*, and other journals even though they could read only a few words of English, and even though some professed not to care about Western art. That compulsive interest in the new can be assigned to an older tradition of modernism, but the sense that the new work can be appreciated immediately, without words or context, is markedly Greenbergian. The Chinese students were anxious that their work would not appear old-fashioned, and the best insurance against that was that it be aligned with whatever was new. By

the standards of North American or European art schools, the Chinese students were also disproportionately attached to painting — another Greenbergian trait. They knew Xu Bing (b. 1955) and other internationally exhibited Chinese artists, but the majority were interested in painting.

In my experience outside North America and Europe, and in general anywhere except major urban centers, painting is likely to be considered the principal visual art. It is easily the most popular visual art worldwide. Part of the reason for that can be traced back to the nineteenth century, when painting was more a universal bourgeois art in the way that piano playing also was; but part of the reason is the invisible dissemination of high modernist ideals, including Greenberg's. This fourth reading of Greenberg usually reveals itself by an anxious interest in the avant-garde, and by an ongoing commitment to painting.

I have discussed Greenberg's writing at greater length than the other theories of modernism because I find it is the most influential. At the same time judging his influence is rarely a question of looking at what he actually wrote beyond the best-known texts, and often enough it is a question not of texts at all but of received ideas.

Greenberg's criticism has come to stand for a trajectory of twentieth-century painting that is widely recognizable. It

forms the backbone of most world-art survey texts, and it is a commonplace in introductory pedagogy. (It leads, roughly speaking, from Manet, Cézanne, Picasso, and Braque through North American abstract expressionism and postpainterly abstraction.) What is more problematic is the continuation of modernist painting following abstract expressionism and color field painting. After the mid-1960s, modernist painting retreated under pressure from minimalism, pop, and new media. The remaining modernist painters — those promoted by Fried and Greenberg, for example — tend to be cited as marginal examples, or to find niche markets. Late in his life Greenberg became interested in a group known as the New New Painting, which includes Roy Lerner (b. 1954; see Figure 1.8), Anne Low (b. 1944), Lucy Baker (b. 1955), Steve Brent (b. 1953), Joseph Drapell (b. 1940), and John Gittins (b. 1940).[38] Their work descends from color field painting of Jules Olitski (b. 1922), Larry Poons (b. 1937), Kenneth Noland (b. 1924), and Helen Frankenthaler (b. 1928), but it incorporates "iridescent 'interference' color, glitter paint, fluorescents, cement-like pumice paint, and metallic paint," and it tends to be focused on the mass and

38. The movement has been cited several times, erroneously, as "New New painters," beginning with an exhibition curated by John Henry, *The New New Painters* (Flint, MI: Flint Institute of Arts, 1999). I thank Lucy Baker, Joseph Drapell, Declan O'Mahony, Kenworth Moffett, Irene Neal, and Graham Peacock for information about the New New painters. There is a Museum of the New New Painters [sic] in Toronto. For Drapell, see www.drapell.com; for Moffett, see http://kenworthmoffett.net/kenworthmoffett; for Graham Peacock, see www.grahampeacock.com.

Figure 1.8

viscosity of the paint.[39] In Roy Lerner's work, stutter-step brush marks put some order into work that is otherwise reminiscent of Hans Hoffman (1880–1966).[40] Brent has experimented with ways of using acrylic gel to create sculpturelike masses of paint that are apparently without support. Several of the New New painters have had formative encounters with modernism and color field painting. Brent was inspired by a 1984 visit to Jules Olitski, and Lerner has said he had a good review from Clement Greenberg and a formative meeting with Kenneth Noland (during which Noland cut his canvases into pieces and made collages out of them).[41]

Because of their modernist genealogy, the New New painters have had publicity problems. The critic David Carrier has noted that even the work of the surviving color field painters was "very hard to properly judge" at the end of the century, and that the "entirely understandable tendency of the New New painters to attach themselves to Greenberg's taste … tends to mark them as nostalgic."[42] There is some disagreement among the New New painters about Greenberg's attitude to New New Painting.

39. John Henry, "Introduction," in *The New New Painters*, 7. The New New painters exhibited at the 69th Regiment Armory in New York City in May 2000; the advertisement in the *New York Times* bills them as "the Real Avant Garde" (May 14, 2000, p. 37). See further Ken Carpenter, "Artist Groups: What's New?" *Art in America* 87 (1999): 51.
40. Roy Lerner, *New New Painting* (Paris: Galerie Gerald Piltzer, 1992), http://www.cw-white-gallery.com/WhiteGallery/Artists/Lerner/lerner.html.
41. Henry, *The New New Painters*, 16, 28.
42. Carrier, "New New Painting and the History of American-Style Abstraction," in *The New New Painters*, 9–11, quotations on p. 10.

Graham Peacock remembers Greenberg found it "not to his taste," but Lucy Baker has encouraging letters from Greenberg.[43] As both Carrier and the critic Donald Kuspit have argued, New New Painting can be described as doing something very different from what Greenberg meant to champion, but I wonder how far from abstract expressionism and color field painting the New New Painting can go as a movement.[44] Gittins is one of the older painters associated with the group; in the 1980s he was making narrow vertical paintings, mostly bare canvas, with paint extruded down the middle in large loops. By the late 1990s he was painting over the whole surface in a manner reminiscent of late De Kooning. Baker's paintings are Pollock-like in terms of gesture but use "marbles, fluorescent and hologramed glitter."[45]

43. Peacock and Baker, personal communications, February 2004. I thank Baker for sending me two facsimiles of Greenberg's letters. Irene Neal recalled that Greenberg critiqued her work, and was interested in it, but she added (in an e-mail to me, February 2004), "I do not think he really got very interested in the NNP." Peacock elaborated, "Greenberg … champion[ed] Lerner and Minkin and Drapell early on, [in the] 70's, but was completely unsupportive of New New Painting, which since 1982 has been outwardly championed by Kenworth Moffett and the French art dealer Gerald Piltzer. Moffett, in fact, fell out with Greenberg in 1986 over his support for my work and that of the NNP. Marcel Paquet of Belgium has also been a supporter since 1992. The inference that Greenberg championed NNP is completely untrue. He in fact supported their unacceptance among his followers and our fellow artists. I continued to have a dialogue with Greenberg, visits for drinks and conversation, to shortly before his death, but he was far from active in support of NNP. He accepted my differing point of view and was interested in our discussion, but he did nothing to aid NNP." But the situation is complex and needs further study. In a second e-mail, Peacock wrote, "There is indeed a strong link [between] the NNP and Greenberg."

44. Again there is some dissent here within the movement; Peacock read a draft of this essay and suggested to me that in saying this I was referring to "the more traditional members of the group"; he considered that "the processes and the way he makes" his own work take it "beyond colour field and abstract expressionism." Peacock also noted that there is evidence Olitski and Poons have been influenced by New New Painting. Personal communication, February 2004.

45. Henry, *The New New Painters*, 12.

The critical framework in which such painting can be seen apart from the legacy of abstract expressionism and color field painting does not yet exist.

The most interesting example of work that is "very hard to properly judge" on account of its proximity to modernist standards is radical painting, a loose group of artists that includes Joseph Marioni (b. 1943), whom Fried has acknowledged as a way forward for painting, through minimalism as it were.[46] To my eye, the most important radical painter is the German Günter Umberg (b. 1942).[47] His signature style paintings are on small rectangular pieces of metal (see Figure 1.9). He sprays a mixture of dry pigments onto the surface, and then sprays fixative on top. He does that forty or fifty times for each painting, creating a surface that appears dry, powdery, and perfectly flat. Some paintings (I do not consider them the most successful) are in bright colors, but most are done with a mixture of very dark pigments so that the paintings appear to be black. Umberg stresses the radicalism of his practice, connecting it with minimalism and claiming it reduces painting to the surface.[48] My own reading is different, because I find traces of gesture in

46. Fried, "Joseph Marioni, Rose Art Museum, Brandeis University," *Artforum* 37 (1998): 149–50; Barry Schwabsky, "Colors and Their Names," *Art in America* 87, no. 6 (June 1999): 86–91; also http://home.tiac.net/~marioni/.

47. For example, *Günter Umberg: Body of Painting* (Cologne: Hatje Cantz, 1987).

48. He also gives hints that he values the painterly properties I experience in the work: for example, "One can seemingly look through [the upper layers] to the (in some cases) red ground." *Günter Umberg met Bernard Frize, Olivier Mosset, Jo Baer* (Deurle, Belgium: Museum Dhondt-Dhaenens, 1998), 35.

Figure 1.9

the painting that make it decisively but incrementally distinct from minimalist physicality.[49] Seen from just a few inches away, Umberg's dark paintings take on an unsurpassable density; it

49. I propose a detailed reading of Umberg in my *Six Stories from the End of Representation* (Stanford: Stanford University Press, forthcoming).

seems possible to detect layers of gestural marks just at the limit of vision. The resulting pictorial space appears impacted, as if it has been crushed into a very slight depth — subjectively, about a quarter inch. The color, too, seems constrained; it is not black but a nearly black mixture of indefinable colors. The effect is like looking at a naturalistic painting in a pitch-black room: space and color seem to be present but compressed and charred. The paintings are at once extremely rich in the possibility of gesture, and nearly (but not wholly) perfect in their adherence to the minimalist notion of flat physical surface.

Umberg is a perfect example of the dilemma of modernist painting at the end of the century. On one hand, if the viewer refuses to countenance the gestural traces in his work, Umberg's painting can be interpreted as a practice faithful to minimalism. On the other hand, if the density and near invisibility of the gestural traces keep the work at an incremental distance from the perfect minimalist surface, then the practice carries on high modernist concerns. In the first reading, Umberg is a perhaps unnecessarily refined heir of Robert Morris. In the second reading, he is an attenuated descendent of Ad Reinhardt. (From close up, the density of Umberg's surfaces is a strong answer to the weakly painted washes in Reinhardt's paintings, but the small scale and precious look of Umberg's work means it cannot compete at a distance.) I would argue for the second option, because it seems to me that Umberg is far more interesting as a

last opportunity for painting after minimalism. Either way, the only available context for interpretation is modernist, and the only terms are those elaborated by Greenberg and Fried. The philosopher Henry Staten has written a long essay on Marioni in particular, claiming radical painting can be understood in terms set forth in Fried's essay "Art and Objecthood."[50] The same discursive field can be used to argue that Umberg "has something of the character of a new beginning" after minimalism, as Fried says of Marioni. In the present context what matters is that Umberg's painting is underwritten by a critical discourse that was applied to only a small number of paintings by the end of the century. His solution to the problem of continuing painting in the terms set out by modernist criticism is the most ambitious I know. The question that cannot be adjudicated within the language of modernism is whether it is significant that so few painters speak that language or take that sense of twentieth-century painting seriously.

50. Henry Staten, "Deconstructing Figurality: On 'Radical Painting,'" in *Günter Umberg*, ed. Hannelore Kersting (Cologne: König, 1989).

2. Postmodernisms

A large portion of the literature on postmodernism in the visual arts is preoccupied with the indefinability of the concept, making it impossible to list variant postmodernisms or to oppose them as a group to the modernisms I have just considered.[1] At the same time it is not capricious to contrast Greenberg's modernism to several kinds of postmodernism exemplified at the end of the twentieth century by Rosalind Krauss, Benjamin Buchloh, Yve-Alain Bois, Craig Owens, Hal Foster, and others who have contributed to the journal *October*. Together, their interests have at times been effectively opposite to Greenberg's, and they constitute the most reflective nonmodernist assessment of the century's painting.

1. A good introduction to literary and philosophic theories of postmodernism is Matei Calinescu, "Introductory Remarks: Postmodernism, the Mimetic and Theatrical Faces," in *Exploring Postmodernism*, ed. Calinescu and Douwe Fokkema (Amsterdam: John Benjamins, 1987), 3–16. Calinescu names among the "early users of 'postmodernism'" Arnold Toynbee, Irwing Howe, Harry Levin, Ihab Hassan, Leslie Fiedler, Daniel Bell, Jean-François Lyotard, Jürgen Habermas, Richard Rorty, Gianni Vattimo, Stephen Toulmin, Douglas Davies, Rosalind Krauss, Guy Scarpetta ("in his important book *l'Impureté*"), and Charles Jencks (quotation on p. 3). The same volume reprints Hassan's "Pluralism in Postmodern Perspective," originally published in *Critical Inquiry* 12, no. 3 (1986), which includes a list of postmodern traits including indeterminacy, fragmentation, "self-less-ness, depth-less-ness," "the unpresentable, unrepresentable," irony, hybridization, carnivalization, and "performance, participation"; *Exploring Postmodernism*, 17–40, quotations on pp. 20, 21.

Krauss has long been the most inventive and outspoken writer in this strain, and yet her work has not been evaluated as a whole or examined for what it might contribute to a nonmodernist sense of the century's painting.[2] Part of the reason, I think, is that her essays are methodologically eclectic, obscuring the consistency of her interests. It may be that Krauss's work has been subject to more disparate interpretations than any postwar art historian. In one reading, her work is scattered, moving from one theory to another without apparent connection; in another, it is curiously nonfeminist despite its repeated focus on women artists; in a third, it is restricted to photography, sculpture, and painting, and therefore out of touch with the current interest in new media.[3] The first reading makes her unreliable, the second and third irrelevant. It may be time to try to come to a more balanced and closer understanding of her work. In particular it seems to me that her writing in the past quarter century has a strong unity that is not brought out by these and other such reductive readings. Her writing also provides an extended description of a particular sense of modernism, against which other theories can be clarified and measured.[4]

2. The only book on her work as a whole is the eccentric encomium by David Carrier, *Rosalind Krauss and American Philosophical Art Criticism: From Formalism to Beyond Postmodernism* (Westport, CT: Praeger, 2002).
3. This last is answered in *Rosalind Krauss, "A Voyage on the North Sea": Art in the Age of the Post-Medium Condition* (London: Thames and Hudson, 2000).
4. This paragraph is excerpted from my online review of Krauss's *Bachelors* (Cambridge, MA: MIT Press, 1999), written in 1999 for the College Art Association's review site www.collegeart.org.

Although Krauss's early writings do posit the end of modernism and the beginning of postmodernism, her later texts increasingly propose postmodernism as a form of resistance that takes place within modernism.[5] That makes it possible to contrast the sense of postmodernism I associate with *October* with another that is more widely known, which sees modernism as a period that has more or less definitively ended.

Arthur Danto is an example, if not a representative, of this second understanding of postmodernism. He located the principal break between modernism and postmodernism in the appearance of Warhol's *Brillo Boxes* in 1964 (see Figure 2.1). After Warhol, in Danto's account, the history of art effectively ended because anything became possible. The art historian Thierry de Duve, despite his more historically engaged account of modernism, is also an example of this second kind of postmodernism. His *Kant after Duchamp* is concerned with the conditions of art following the decisive appearance of Duchamp's *Fountain* in 1913.[6] (Danto and de Duve have friendly but deep disagreements. In Danto's view what happened in 1913 was a matter of epistemology, not ontology; he has argued that a viewer's knowledge will not meliorate the problems raised by the *Brillo Boxes* in the way that it can come to terms with *Fountain* and its plumbing-store clones. Yet

5. This is explicit in the texts I am discussing here and stated differently, in terms of a "closure" of modernism, in *The Originality of the Avant-Garde and Other Modernist Myths* (Cambridge, MA: MIT Press, 1985), 6.
6. Thierry de Duve, *Kant after Duchamp* (Cambridge MA: MIT Press, 1996).

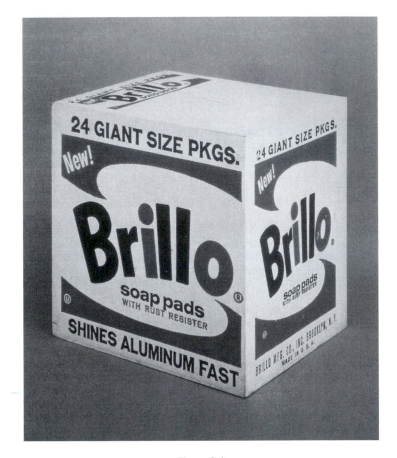

Figure 2.1

Danto and de Duve share accounts that depend on originary moments, and from that wide-angled perspective the stories they tell are eerily similar.) Other writers including Thomas McEvilley, Donald Kuspit, Robert Rosenblum, and Leo Steinberg have located the moment of transition from modern to postmodern in pop art, and especially in Johns, Rauschenberg, or Warhol. After pop, so these arguments go, art became eclectic or pluralist

and began addressing the condition of late capitalism. The kinds of painting done by Alex Katz (b. 1927), Jonathan Borofsky (b. 1942), Komar and Melamid (b. 1943, 1945), Kenny Scharf (b. 1958), and Damien Hirst (b. 1965) — to name six examples of painting informed by pop art — differ fundamentally from superficially similar modernist work. Hirst's splatter paintings, for example, are spoofs of gestural abstraction and color field painting. I imagine that Scharf's painting is too goofy and unserious even for some defenders of pop, and so it marks the transition especially clearly. His paintings of artists as clowns are a case in point. Painters such as Fairfield Porter (1907–75), Avigdor Arikha (b. 1929), William Bailey (b. 1930), Jack Beal (b. 1931), Claudio Bravo (b. 1936), and Antonio López-García (b. 1939; see Figure 2.2) — to name six painters whose styles do not descend from pop — can then be considered leftovers of modernism or older periods.

It is not widely noted that this sense of postmodernism is just as strongly opposed to Greenbergian modernism as the first *October*-style postmodernism. Abstract painting, for Greenberg, is a necessary result of the pressure exerted by the history of painting on the present; for Danto abstraction is just one of many possibilities open to painting, with no historical necessity left to it at all. Danto's liberatory aesthetics is common to many writers who have associated the beginnings of postmodernism with pop or with performance, earth art, or multimedia. It is the sense of freedom, more than anything else, that marks this second strain

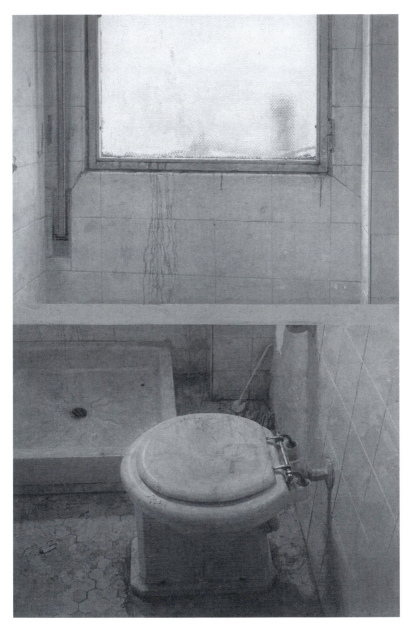

Figure 2.2

of postmodernism apart from Greenberg's modernism. There is no longer a historical argument that can reject Scharf or support Umberg: a liberating fact for some critics and artists, and a loss of historical awareness for others.

In the first kind of postmodernism, the one I am associating with *October*, nothing unambiguously supplants modernism. Postmodernism is not the name of a period, such as neoclassicism or postimpressionism; it is a condition of resistance that can arise wherever modernist ideas are in place. Postmodernism works like a dormant illness in the body of modernism: when modernism falters and fails, postmodernism flourishes.

Yve-Alain Bois's description of Manet's *Olympia* provides an interesting example (see Figure 1.2). He opened the book *Formless: A User's Guide* with a discussion of two ways that Manet's painting was received. In the first reaction Manet was taken to be the first modernist painter because of the work he did against "technical, painterly values," especially by painting the model's skin so flatly that it seemed pressed into the fabric of the canvas. Bois mentioned Émile Zola and Charles Baudelaire as contemporaneous examples of this kind of reaction and then introduced Greenberg as the central recent example.[7] The second reaction focused on the painting's subject matter. Viewers were

7. Yve-Alain Bois, "The Use Value of 'Formless,'" in *Formless: A User's Guide*, ed. Yve-Alain Bois and Rosalind Krauss (New York: Zone, 1997), 13–40, quotation on p. 13. "Technical, painterly values," quoted Françoise Cachin, entry for "Olympia" in *Manet 1832–83*, trans. Ernst van Hagen and Juliet Bareau (New York: Metropolitan Museum of Art, 1983), 176. (Formless, 13 and 256 n. 2.)

confused, astonished, and embarrassed by what the painting
seemed to admit about prostitution and about what are now
called race relations. Together the two reactions replayed "the old
metaphysical opposition" between form and content, which Bois
said is ubiquitous in the literature on Manet, with just a few
exceptions. (In an important and elliptical footnote, he named
Georges Bataille, Fried, and Clark.)[8]

The two kinds of responses, as he describes them, can be
identified with two of the theories I am reviewing here: the
first with Greenbergian high modernism and the second with
a theory about art and politics, which I will consider later.
The postmodernist move in this dilemma, according to Bois,
is to opt out of the duality altogether. He said the *Olympia*
is important not on account of its flat paint handling or its
unflinching exposure of prostitution but because its mixture of
qualities disabled the language of criticism. The painting failed
to work, to be usable as a painting. It failed in the only way
that failure can be genuinely meaningful from the perspective
of the book *Formless*: by continuing to operate, but incorrectly
and unpredictably. Following Bataille, Bois said the painting
acted on contemporaneous audiences like grit in the machine
of modernism:

8. *Formless*, 13 and 256–57 n. 5. Because Bataille is central to *Formless*, the footnote is largely
 a catalog of differences between Bataille's reading and major art historical readings — such
 as Fried's and Clark's — which are not merely "form" or "content." Bois and Krauss note
 that "Clark makes only one reference to Bataille," and the footnote ends, "Fried's Manet is
 the founder of an ontological unity; thus, he is the polar opposite of Bataille's."

If the *Olympia* caused a scandal, Bataille argues, it was because by means of it Manet refused the various ideological and formal codes regulating the depiction of the nude, whether erotic, mythological, or even realistic (Courbet didn't like it). Manet's subject is not located "anywhere," Bataille says.[9]

It is interesting that the historian Briony Fer has made a remarkably similar argument, even contrasting the two competing interpretations of the *Olympia*, but she ends by concluding that it is the first modernist painting. In her view the *Olympia* is about not just its technique or its subject "but rather a combination of a problematic subject with a disconcerting way of painting." The "modernity of *Olympia*," she concludes, "lay partly in the critics' failure to see that modernity."[10] In Bois's essay that same challenge to existing criticism is evidence that the *Olympia* is at once an enactment of modernist ideas and also a fundamental opposition to those same ideas. I take the divergence of Bois's and Fer's readings as a warning that analyses done at this level of abstraction can be slippery. What matters in this context is that both writers reduced the contemporaneous responses to two groups and then identified their disagreement in terms of two of the principal theories I am setting out here.

9. *Formless*, 15, sentence truncated in the quotation.
10. Fer, "Introduction," in *Modernity and Modernism: French Painting in the Nineteenth Century*, with contributions by Francis Frascina, Bigel Blake, and others (New Haven, CT: Yale University Press, 1993), 3–49, quotations on p. 25. Fer's own working criterion for modernism is "difference"; I have not included it here because it is not clear to me how it picks out modernism from other, earlier movements.

Formless is a dictionary of possibilities for disabling the modernist machine, and each of its ideas can be enlisted as an additional criterion of what I am identifying as postmodernism: the anarchic informe, Bataille's notion of an operation that wrecks sense and system; horizontal works as opposed to conventional vertical paintings; bodily engagements as opposed to Greenberg's insistence on optical responses; outbreaks of irrationality as opposed to modernist logic; the unconscious as opposed to modernism's relentless analysis; the "base materiality" of paintings as opposed to their use as vehicles of illusionism or covert idealism; and formlessness as opposed to classical figuration. There are a dozen other criteria arranged as short chapters. The analytic heart of *Formless* is the operation of the informe, which produces a kind of ruin that cannot be folded into classical logic.[11] Several of the most important concepts circle around the informe, including the central role of illogic and the necessity of the absence of systematic theory. An artwork can be prone to failure, in Bois and Krauss's view, if it proceeds blithely and naively to endorse systematic meaning — including, for example, the putative form–content debate around Manet's *Olympia*. Art that is interesting in the terms

11. Elsewhere I have explored the way that Krauss grounds a similar principle of irrationality in Jean-François Lyotard's concept of the matrix. It is not an easy project to theorize (i.e., in the strict sense, to argue rationally) about a concept that works against rationality in some specific (again, and strictly, logical) manner. Lyotard's matrix is arguably central to Krauss's effort in her book *The Optical Unconscious*, and the informe is declaredly central to *Formless*. See my *On Pictures, and the Words That Fail Them* (Cambridge: Cambridge University Press, 1998), 103–10, 255–56; and further Krauss, *The Optical Unconscious* (Cambridge, MA: MIT Press, 1993), 190. A review that touches on these questions is Ben Highmore, "Spiders, Spit, and Frock Coats," *Art History* 22, no. 1 (1999): 136–42.

proposed in *Formless* does not so much simply fail as demonstrate the knowledge that works in the modernist sense is also failure, that the crumbling modernist edifice cannot be shored up, and even that the crumbling may be the most interesting thing about it.

Formless paints a picture of twentieth-century painting very different from Greenberg's. Krauss and Bois wrote about the Rauschenberg (b. 1925) of the dirt paintings, Lucio Fontana (1899–1968), Cy Twombly (b. 1928), and Jean Fautrier (1898–1964), but painting is not privileged. Surrealism is preeminent — it is the inverse of Greenberg's low opinion of surrealism and his advocacy of abstraction. The kind of postmodernism I am associating with writing in and around *October* implies a very different shape to twentieth-century painting: the medium is in question, and only its most marginal and philosophically skeptical moments are allowed. The genealogy of high modernism — the route from Cézanne and Picasso through abstract expressionism — is replaced by a family tree that goes from Dada and surrealism (but especially surrealist photography, not painting) through anti-art, Fluxus, performance, and video: a measurably different sense of the century, and the most important alternative to the modernisms I have named.

The way this works in a textbook format is shown by *Art Since 1900*, co-authored by Krauss, Bois, Benjamin Buchloh, and Hal Foster. Because their book has a pedagogic purpose, they are compelled to include artists that fall outside their central interests. The brief appearances are telling: Julian Schnabel,

David Salle, and Francesco Clemente are mentioned in passing, mainly in order to point out that their practices are not serious engagements with modernism. Such "elitist" and "manipulative" "neoconservative postmodernism," the authors say, was effectively engaged in an "antimodernist" attempt to shut down the "critical aspects" of modernism. Francis Bacon, who is held in low regard by the authors, barely makes it into the book in a passing reference.[12] Soutine, Modigliani, Utrillo, and Dufy — markers of the ever-popular Style of Paris — are either wholly absent or mentioned, without description, in passing. Balthus is omitted, and Bonnard gets two brief paragraphs. Cubism figures prominently, but it could be argued that the discussion is more succinct than in the modernist textbooks produced by the Open University. The differing interests of the book's four authors mean that *Art Science 1900* includes elements of modernism and of what I am calling "Politics" (especially in sections written by Benjamin Buchloh), although it is telling that the fourth approach I am exploring here, the importance given to skill, is barely touched upon in a short, anomalous chapter on Soviet Socialist Realism that includes such painters as Isaak Brodsky (1883–1939), best known as Lenin's portraitist. The potential for aimless diversity that mars several popular textbooks of twentieth-century art is is controlled by the authors' consistent interests in the politics of

12. Foster, Krauss, Bois, and Buchloh, *Art Since 1900: Modernism, Antimodernism, Postmodernism* (London: Thames and Hudson, 2004), 597, 424 respectively.

resistance, conceptual challenges, and transgressive innovations, making *Art Science 1900* a moment of exemplary clarity in the stream I am identifying — as always, for these purposes and in this context — with postmodernism.

There is a reading of Krauss's project, and of *October*, that stresses their dependence on Greenbergian high modernism and their closeness to generative modernist concepts such as formalism. In an extreme version of this reading, *Formless* and affiliated texts are read as continuations of the modernist project. There is much to be said for that interpretation; *Formless* is, after all, largely a series of opposites to Greenbergian ideas, so it can remain trapped in a modernist dialectic despite its authors' intentions. I am not following that reading here, however, because *October* has considered artists and artworks that are significantly different from the ones that have been taken as pivotal in modernist scholarship. In that respect *October* and Krauss's work in particular are the principal alternatives to modernist histories of the century.[13]

The marginal interest in painting among *October* writers, and their emphasis on surrealism, means they have a taste that is in the minority among consumers of twentieth-century art. That has been quantified several times. A Columbia University survey of American newspaper art critics found a low level of knowledge of *October* and the principal art

13. See, for example, Paul Hegarty, "Formal Insistence," review of *Formless* in *The Semiotic Review of Books* 13, no. 2 (2003): 6–9, and *Formless: Ways In and Out of Form*, ed. by Patrick Crowley and Paul Hegarty (Oxford: Peter Lang, 2005).

historians associated with it.[14] The 1995 edition of the *Guide to the Art Market* noted, "The Surrealists always appealed to a narrower, more intellectual band of collectors than those who bought Impressionist pictures."[15] Most buyers are Europeans, the anonymous writer noted, with a "flurry" of activity from Americans and Japanese at the time of the art boom in 1988 to 1990.[16] Yet in my experience *Formless*, and Krauss's work in general, captured the interests and sense of history of a large percentage of art students and academic historians at the end of the century.

Writing in and around *October* also defines interests in late-twentieth-century painting that are distinct from the preferences of writers such as Danto, for whom pop art was the definitive inauguration of postmodernism. The art historian Stephen Melville, for example, has worked on postwar French abstraction, support–surface, and conceptual art, including Daniel Buren (b. 1938), Martin Barré (1924–1996), Jean Degottex (1918–1988), Mel

14. András Szántó et al., eds., *The Visual Arts Critic: A Survey of Art Critics at General-Interest News Publications in America* (New York: Columbia University National Arts Journalism Program, 2002), 67; sixty-seven percent of respondents said they were "not familiar enough" to rate *October.*
15. The edition I have consulted is *Guide to the Art Market/Guide du marché de l'art*, ed. Jacques Dodeman (Paris: Le Journal des Arts, 1995); the quotations are on pp. 120–21. Individual surrealists vary widely: Dalí's prices were still low in 1995, possibly because of the many forgeries that continued to circulate; prices for Klee had declined 24 percent since 1989; but a "mainstream Miró" had climbed only 190 percent since 1975 — a disappointing show when it is measured against other modern painters.
16. "The striking variation in performance" among the surrealists is attributed to "special factors including the degree of cerebral 'difficulty' or challenge presented by each artist's work" — with difficulty in quotation marks to signal that it is more perceived than real. "Marx Ernst is a classic example of a 'difficult' artist," the *Guide* observed. "Over 700 works by the artist have sold at auction since 1975, but the average price has increased by just 19% to FF236,000"; *Guide to the Art Market*, 121.

Bochner (b. 1940), Daniel Dezeuze (b. 1942), Simon Hantaï (b. 1922), and James Welling (b. 1951).[17] Others have written about intentionally weak vernacular painting such as Luc Tuymans's (b. 1958), digital painting (including animated abstraction shown on flat screen displays), and recent fine-art airbrush painting. In general, writing informed by *October* has created a new sense of the course of twentieth-century painting. The century begins with cubist and Dada collage (taken, in part, as challenges to the autonomy of painting); includes some of Duchamp's works such as *Tu m'* (see Figure 2.3) and the *Rotoreliefs* (because they critique what Duchamp called "retinal painting"); and takes in Fontana, Dubuffet, Pollock, and Warhol (painting practices that stress painting's materiality by incorporating holes, dirt, cigarette stubs, and urine). The *October* trajectory also includes minimalism and postminimalism, understood as mainly composed of nonpainters but including Bochner and Keith Sonnier (b. 1941), in part because minimalism and postminimalism effected a different critique of what Duchamp called retinal painting.[18]

There is apparently no end to theories of postmodernism in twentieth-century painting, and it is likely that no single historian has read more than a fraction of the available literature. Yet there are remarkably few theories that result in a different sense of the principal movements and artists; I find that the two principal variants I have introduced here cover the field remarkably well.

17. Philip Armstrong et al., eds., *As Painting: Division and Displacement* (Cambridge, MA: MIT Press, 2001).
18. Stephen Melville, "What Was Postminimalism?" in *Art and Thought*, ed. Dana Arnold and Margaret Iversen (London: Blackwell, 2003), 156–73.

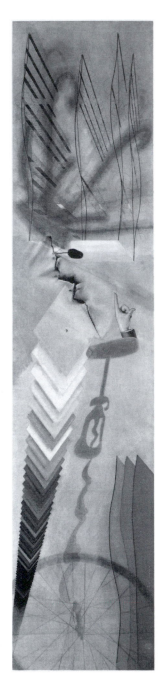

Figure 2.3

3. Politics

Under this heading I include any writing on the previous century's painting in which one of two concerns guide the writer's sense of the work's importance: either the work's ethics or the social setting in which the work was made. The former has no name, although it could be named moral art criticism. The latter is usually called social art history.

There are other senses of politics, which might be the ones most readily conjured for readers who are invested in postmodernisms; in those perspectives art's politics goes to its root, making every aesthetics a politics and every art practice the enactment of a politics. Those senses of politics have been put into practice since the 1960s in performances, collaborations, and interventions of many kinds. They also have been theorized as institutional critique (by Benjamin Buchloh, Hal Foster, and Donald Preziosi, among others), as an expanded aesthetics (by Jean-Luc Nancy, Marc Redfield, John Paul Ricco, and others), as Marxist or Marxian critique (for example, by Karl Werckmeister and very differently by Terry Eagleton), and as identity politics and gender theory

(by Judith Butler, Douglas Crimp, Leo Bersani, and others).[1] These are different practices, and it is not fair to present them as a single movement, except that they diverge from shared ideas about the identity of aesthetics and politics. For readers who are sympathetic with one of these perspectives, this section will likely seem inadvisable or unsupportable, for several reasons: because "Modernisms" and "Postmodernisms" (and perhaps especially the latter) already are politics, even though I have not acknowledged that in the discussion; because social art history and moral art criticism have their own politics, which should not be confused with the understanding of aesthetics as politics; and because postmodernisms cannot be understood apart from political critique. I do not argue against any of those objections, or against Nancy's understanding of aesthetics, which I take it is in many ways fundamental. My reasons for separating "Politics" in this section, and identifying it mainly with social art history and moral art criticism, follow from the general remarks I made about theory at the beginning. I find that studies informed by politics in the more fundamental sense have not yet proposed enough previously neglected artists to affect the balance of the discipline's customary subjects.

1. In addition to the following sources, see Donald Preziosi, *Brain of the Earth's Body: Art, Museums, and the Phantasms of Modernity* (Minneapolis: University of Minnesota Press, 2003); Jean-Luc Nancy, *The Sense of the World*, trans. Jeffrey Librett (Minneapolis: University of Minnesota Press, 1997); Marc Redfield, *The Politics of Aesthetics: Nationalism, Gender, Romanticism* (Stanford, CA: Stanford University Press, 2003); and John Paul Ricco, *The Logic of the Lure* (Chicago: University of Chicago Press, 2002).

Some writing that stresses ethics and social context is produced in universities by art historians who are concerned with political history. But most of it, and especially the kind of writing that might be called moral art criticism, is written outside academic circles; it can be found in the literature of art academies in Soviet Russia and in China, and in different forms, in newspaper journalism, conservative commentary, and the pronouncements of politicians. At the end of the century in the United States, the two most prominent politicians in this category were Senator Jesse Helms and New York City mayor Rudolph Giuliani. Among critics, the most widely read were probably Hilton Kramer and Roger Kimball.[2]

The writers of moral art criticism are diverse in their politics, but they share the formative idea that art should be moral and ethical, instructing people rather than, say, confusing or shocking them. As such, moral criticism is ancient and widespread. Its roots are in the Plato of the Republic, and by extension in orators from Demosthenes and Isocrates to Cicero. I estimate that in the twentieth century, moral criticism was far more common than any of the other kinds of writing I am considering here except the next theory I consider, that painting depends mainly on the painter's talent.

2. See, for example, Jesse Helms, *When Free Men Shall Stand* (Grand Rapids, MI: Zondervan, 1976); Hilton Kramer, *The Age of the Avant-Garde: An Art Chronicle of 1956–1972* (New York: Farrar, Straus and Giroux, 1973); and Hilton Kramer, ed., *The New Criterion Reader: The First Five Years* (New York: Free Press, 1988).

In South Korea, for example, conservative traditions of art education at the secondary school level continue to produce students who believe that art should have a clear ethical purpose or message, and who are unconvinced by the Western modernist and postmodernist interest in ambiguity and complexity. I cannot quantify this observation, and it does not apply to working artists, but I have observed it for a number of years among Korean art students and intermittently among students who are Chinese, Japanese, Thai, Vietnamese, Singaporean, Malaysian, and Laotian. In Korea an ethical attitude to visual art can be attributable to the persistence of a rigid system of art instruction based on French Academy models of naturalism, combined with Soviet socialist models of narrative subject matter.[3]

Given the heterogeneity of moral art criticism, it is important to notice how moral interpretations differ from judgments made from modernist or postmodernist perspectives. Consider, for example, Diego Rivera's (1886–1957) mural *Man, Controller of the Universe*, originally commissioned by John Rockefeller Jr. for the Rockefeller Plaza in New York City (see Figure 3.1). Rivera was paid and dismissed when Rockefeller could not get him to remove a portrait of Lenin. Rivera then painted the same picture — on a smaller scale, but with more figures on either side — for

3. The conservative students I have encountered are often the educational products of "cram" schools (*misul-hakwon*), which have become an industry in Korea. They teach beaux-arts–inspired skills to students, in preparation for their university exams. Many are located near HongIk University and in DaeChi Dong; see www.milsulsam.com. Still, the universities play the major role in the dissemination of art practices. I thank Joan Lee for this information.

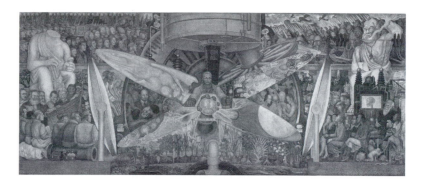

Figure 3.1a

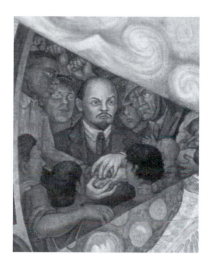

Figure 3.1b

the Palacio de Bellas Artes in Mexico City, and the episode helped make him a household name in the United States. The painting is openly political and revolutionary. A scene of "superficial, frivolous" capitalist "debauchery" with a portrait of Rockefeller (at the middle left) is contrasted against a picture of brave socialist action, which includes portraits of Marx, Engels, and

Trotsky (at the right).[4] The scandal following the unveiling of the original painting in the spring of 1933 provoked some incisive political criticism. An anonymous writer in *The New Republic* wrote that Rivera's determination not to remove the portrait of Lenin "may appear to prevent all defense of his work on the ground of its art, or because the artist is superior to politics. Certainly it has calmed the enthusiasm of many of his bourgeois partisans."[5] An anonymous *New York Times* editorial proposed the mural would have made better sense at 26 Broadway, where the Rockefeller family offices had been located, rather than in Rockefeller Center, where the fortunes were being distributed "in manifold benefactions."[6]

Social art historians and moral critics have placed a consistently high value on Mexican muralism, and in particular on Rivera; a valuation that is not at all shared by modernist historians, for example, for whom Rivera is an example of belated figurative art that is out of touch with the central developments of midcentury painting. From a modernist point of view, if *Man, Controller of the Universe* is not a central work in twentieth-century painting, it may be because of Rivera's dependence on what he called "Anáhuac" cubism, on the filmmakers Sergey

4. "Frivolous" and "superficial" is from Sofía Rosales y Jaime, in *Diego Rivera, Catálogo General de Obra Mural y Fotografía Personal* (Mexico City: Instituto Nacional de Bellas Artes, 1988), 184; "debauchery" is from Cynthia Helms, ed., *Diego Rivera, a Retrospective* (New York: Norton, 1986), 304.

5. *The New Republic*, May 24, 1933, 49, quoted from Irene Herner de Larrea et al., eds., *Diego Rivera: Paradise Lost at Rockefeller Center* (Mexico City: Edicupes, 1987), 122.

6. *New York Times*, May 16, 1933, 35, quoted in *Diego Rivera: Paradise Lost*, 108.

Eisenstein and Dziga Vertov, and on painters from the School of Paris: all sources that cut him off from modernist developments in painting after World War I.[7]

I cannot see how it is possible to subdivide moral criticism, as I have done with modernisms and postmodernisms, because there is an array of positions from those who work only as scholars to those for whom any study of modernism entails an active politics. For some social art historians, the study of anarchism and socialism can now be carried out only in the academy, so that the interaction of politics and art becomes a field of study that may not involve political activism. Writers such as Mark Antliff, Patricia Leighten, and T.J. Clark have considered anarchism and socialism in art from within academic settings; that implies not a quietism (as the critic Dave Hickey implied when he said he would write a book called *Fabulous Mansions of Marxist Professors*) but a conviction about the state of affairs in the contemporary world.[8] Other social art historians such as Thomas Crow, Stephen Eisenman, Donald Preziosi, and Hal Foster are interested in more abstract questions of the relation between art and society that would not necessarily lead to a specific intervention in politics — or that would lead to interventions that are political only in the sense that they are aimed at art-world practices, museology, or curatorial practices. For others, including

7. David Craven, *Diego Rivera as Epic Modernist* (New York: G.K. Hall, 1997).
8. Hickey, personal communication, 2001.

Werckmeister and Katy Deepwell, the social setting of modernist art implies that any scholar should be engaged in politics outside the art world. In still other cases a generative theory that does not involve political action, such a Buchloh's, has given rise to artists and scholars who find such action necessary (e.g., the artists Gregg Bordowitz and Andrea Fraser, who were influenced by Buchloh).

Superimposed on that array of possibilities is the conventional political spectrum from anarchists (perhaps including Antliff) and pyrrhonists (McEvilley), through various left- and right-wing academics, all the way to antiacademic Republican neoconservatives such as Kramer and Kimball. The middle portion of the spectrum is especially complicated. Clark's politics are strong but also enfolded in what readers have felt is a kind of melancholy (it is at least a disappointment over the paltry successes of modernism, and modernism's sometimes unhelpful optimism).[9] My sense is that most of social art history takes place in a turbid middle ground where particularly academic if not conservative choices of artworks mingle with liberal politics, and where the philosophies of modern art can work subtly against political will. It is a difficult enterprise to disentangle the discipline into legible politics. It is easier, and more appropriate to my current purpose, to look at the extreme positions.

9. For an activist perspective on the political valence of that apparent melancholy, see Werckmeister's review of *Farewell to an Idea*, "A Critique of T.J. Clark's *Farewell to an Idea*," *Critical Inquiry* 28 (2002): 855–67.

(A note on the consistency of my exposition. The disarray of the accounts I want to talk about under the heading "Politics" also makes it impossible to arrange them according to where their authors place the inception of modernism. That arrangement, I think, captures much of the range of ideas about modernism, and it is still pertinent when it comes to postmodernisms. The different exposition I am attempting in this section reflects the fact that these are not theories in the strong sense but accounts, models, narratives, and other kinds of writing. To some degree they require an opportunistic and even inconsistent approach: sometimes it helps to look at the times that movements were thought to have originated; in cases like the journal *October* it can be more fruitful to explore leading concepts. Now, considering politics, it seems best to examine a few test cases and exemplary writers. If writers on twentieth-century art were guided by theories, then the entire subject I am assaying would be intrinsically easier.)

Here is how Hilton Kramer summed up his obituary notice for the gallerist Leo Castelli (the piece is titled "The Man Who Turned Kitsch into Art"): "Pop art certainly had the effect of lowering the level of taste in every quarter of the art world. ... Minimalist art had the parallel effect of introducing a vein of nihilism into the art scene that continues to prosper to the present day." "The most celebrated nihilist," Kramer said, is Duchamp. He was elevated "to a kind of sainthood," an event that was "one of the greatest disasters to befall our art and our art institutions." At the end Kramer allowed that his "has been

a dissenting opinion in an art world that is now a sillier, more venal and more dispiriting place than it was in the days before Leo Castelli."[10] Here Kramer sounds like a high modernist writing against art that is dependent on politics, but his criticism is wholly moralizing in tone and purpose. He wants inspiring, ethically responsible art and not kitsch, identity politics, and other "sillier" forms of personal expression.

At the other end of the political universe is writer Thomas Crow, who has very reflective things to say about the relation between some postwar art and its surrounding culture. His approach does not involve advocating any particular politics, but his interest in the most challenging minimalist and conceptual art means he is uninterested in much of the art of the same decades, art that other postmodern criticism finds most promising. (He is unimpressed, for example, by much of what happens under the aegis of visual studies.)[11] Crow has written about Sherrie Levine's (b. 1947) plywood paintings, Peter Halley (b. 1953), Christopher Wool (b. 1955), and even Ross Bleckner (b. 1949) but not, for example, about intentionally kitschy or unserious postpop and neoexpressionist painting such as David Wojnarowicz (b. 1954), Julian Schnabel (b. 1951), or Kenny Scharf (b. 1958).[12] For Crow "the most powerful moments of modernist negation have occurred when the two aesthetic orders, the high-cultural and subcultural,

10. Kramer, "The Man Who Turned Kitsch into Art," *New York Times*, August 25, 1999, A16.
11. For further discussion, see my *Visual Culture: A Skeptical Introduction* (New York: Routledge, 2003), 19, 47–48, 59–60.
12. Crow, *Modern Art in the Common Culture* (New Haven, CT: Yale University Press, 1996).

have been forced into scandalous identity, each being continuously dislocated by the other": the scandals in question are philosophic challenges, not popular culture entertainments or superficially political controversies as in Chris Ofili's (b. 1968) painting in the New York showing of the Sensation exhibition.[13] For Crow, successful work is able to "dislocate the apparently fixed terms" of the hierarchy between high and low culture, making it into "new and persuasive configurations."[14] Neoexpressionist painters such as Ofili have no place in the historically and philosophically committed encounter of avant-garde and popular culture because they do not alter the configuration of what is taken to be high and low. For that reason Crow has not been engaged by political art such as the Guerrilla Girls: that kind of collage of political message and artistic context is, in context of Crow's critique, too easy. It is more difficult than that to put art and politics in productive conjunction.

Among the accounts of affinities of modernism and its political contexts, Crow's is the most conceptually precise and unremittingly skeptical. For him it is not enough for the artwork to reflect or express its society (this, it can be argued, is the default model for social art history) or for the society to reflect the art. Both possibilities affect one side of the relation and leave the other untheorized. And it is not adequate to picture the avant-garde as an essentially independent force that gathers its materials mysteriously (this model could be associated, for example, with

13. Ibid., 26–27.
14. Ibid., 33.

Adorno) or to construe social art history as the study of culture in its entirety, including whatever artworks, political events, and other ingredients appear relevant. That last option is a common one among social art historians and new historicists, but from Crow's perspective it can be said that accounts that juxtapose culture, politics, art, gender, and many other things, without proposing how, in any given case, the artworks in question possess their meaning or efficacy, are undertheorizing their task.

It can seem that Crow's unprescriptive, politically open-ended but philosophically narrow and demanding analysis is broadly consonant with less politically engaged academic writing, and that is generally the case. To some observers, however, his approach appears strongly distinct from what I have been calling postmodernism. David Carrier found Crow's assumptions "absolutely implausible"; Carrier said he suffers an "absolute inability to explain or understand why [Crow] makes this obviously futile attempt to divide artworks ... into those that are good because they are politically critical" and those others that fail because they do not engage politics.[15]

Rather than try to subdivide kinds of moral criticism, I want to describe some case studies that seem to triangulate the field reasonably well. The painter Leon Golub (b. 1922) has long defended the realism of his political painting against

15. Carrier, "Methodologies and Theory; Old and New," *Art Journal* 56, no. 2 (1997): 93–95, especially p. 94.

"modernist/postmodernist dilemmas of appearance, representation, 'appropriation' and 'false consciousness,' " all of which make people anxious about "what is real as against what is 'real.' " His subjects, he said, are "as real to what's going on as any late model automobile, postmodernist architecture, or any arch fracturing of self by which an artist claims to gain autonomy."[16] Golub has been defended by several critics who are otherwise postmodern in orientation (they are interested in the things Golub disparages in this passage), but Golub's own sense of the painting of the past half century does not include much of the video and performance art that those critics also praise.[17] Golub likes to talk about his political subjects without speaking of them as representations. In one interview, he said that an object in one of his paintings is a brank: a European torture device, also called a "scold's bridle," that was used to silence women and also to break the mouth and other orifices. He spoke as if the painting contained a brank, rather than representing one. Soon after, he fielded the inevitable question about his reputation: "I'm elevated and frustrated at the same time. The paintings are very dominant in their appearance and it may be that for much of art world taste, I am too much."[18] Golub's success, in the art world, is due partly to viewers who

16. Golub, "American Myths" (1986), reprinted in Hans-Ulrich Obrist, ed., *Leon Golub: Do Paintings Bite? Selected Texts 1948–1996* (Ostfildern: Cantz, 1997), 67.
17. For example, Jon Bird, *Leon Golub: Fragments of Public Vision* (London: Institute of Contemporary Art, 1982), with an interview conducted by Michael Newman.
18. "The Sledgehammer and the Dagger — A Conversation between Leon Golub and Avery Gordon" (1999), in *Leon Golub: While the Crime Is Blazing, Paintings and Drawings 1994–1999* (Lewisburg, PA: Bucknell Art Gallery, 1999), 14–22, quotation on p. 19.

want immediate political and real-world content, and partly to postmodernist critics who are intrigued by his openness about representation. Some of his frustration is due to the viewers who are concerned about his lack of attention to modernist issues of painting or to postmodern "dilemmas of appearance, representation, 'appropriation' and 'false consciousness.' "

Work that is openly political is most likely to cut itself off from the approaches I am characterizing as modernist and postmodernist. Some historians argue that it is no longer possible to create work that fuses political and other sources of meaning. The argument is well put by Stephen Eisenman at the end of a book on nineteenth-century art:

> "As eminently constructed and produced objects," Adorno writes,
> "[autonomous artworks] point to a practice from which they abstain:
> the creation of a just life." To combine perception and apperception,
> the sensual and the cognitive, the intellectual and the emotional within
> a single work of art — so Adorno argues — is to betoken a totality
> that is absent in a world scarred and fragmented by modernization and
> an exclusive reliance upon reason. Cézanne strove to achieve totality in
> his art, and in so doing insinuated his criticism of society in the very
> form of the artwork itself. That formal insinuation — the achieve-
> ment both of a single artist and of the generations that labored before
> — may be judged, however, a failure as well as a success. During
> Cézanne's last years, and especially in the decades that followed, the
> embedding of criticism in form came more and more to resemble a

hibernation of criticism. Indeed, by the time Cézanne was rediscovered by a public familiar with Cubism and abstraction, art and cultural criticism inhabited wholly separate spheres. The story of that fateful segregation cannot be told here; the effort of the present book has been only to show that in the nineteenth century things were different, and that the best art was critical.[19]

If the split between the "intellectual and the emotional" — in this context, it is better to say the political and the aesthetic — was last patched by Cézanne, then it never has been possible to believe in Childe Hassam's (1859–1935) patriotic flag paintings, made ten years after Cézanne died, not to mention Golub's leftist paintings from nearly a century later. Hassam's flag paintings are postimpressionist urban panoramas in the tradition of Pissarro but with the streets filled with American flags (see Figure 3.2). Even if it were possible to agree that Hassam "transformed" the Red Cross flag "into a symbol of great majesty and presence" in *Red Cross Drive, May 1918* or to join in the exuberant internationalism of paintings such as *Avenue of the Allies: France, 1918 (The Czecho-Slovak Flag in the Foreground, Greece Beyond)*, the paintings would still have to be taken more as illustrations of politics than as political paintings.[20]

In popular art there is no sign of doubt regarding the compatibility of political messages and art. I have in my files a

19. Eisenman, "The Failure and Success of Cézanne," in *Nineteenth Century Art: A Critical History* (London: Thames and Hudson, 1994), 351.
20. Ilene Fort, *The Flag Paintings of Childe Hassam* (New York: Abrams, 1988), 17.

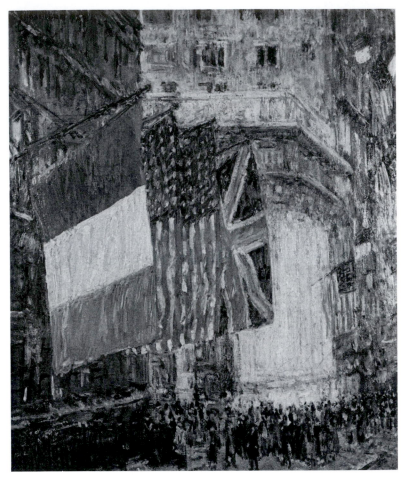

Figure 3.2

number of examples. Dean Mitchell is a commercially successful
African American watercolorist; he won the 1998 grand prize in
the Adirondacks National Exhibition of American Watercolor
for a painting called *The Citizen* (see Figure 3.3). It shows an
elderly African American man slumped in a metal folding
chair in an empty room, American flag to one side. Mitchell

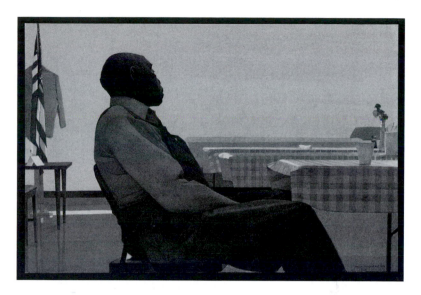

Figure 3.3

won over hundreds of other contestants whose pictures are not about race or ethnicity. In 1999 I visited a state auction in Romania, one of several that had been set up to dispense with Ceaușescu's belongings. I toured rooms full of gifts that had been given to the Ceaușescu family: gloves, caps, socks, vases, masks, wardrobes, kimonos, bronze pigeons, chandeliers, bowls, pajamas, photo albums, sleds, trunks, thrones, Persian rugs, elephant tusks, lamps and lampposts, and things the catalog just called "gewgaws" and "knink-knacks." There were many paintings with flattering depictions of the Ceaușescu family; one was described as "Sewn picture 'N.C. Family,' " another as an "Ivory picture framed by two teeth" from Somalia. Most astonishing was a painting described as "An 'Anniversary' Canvas (N. Ceaușescu and E. Ceaușescu proposing a toast with Stephen the Great from

Figure 3.4

the painting)": in the picture, Stephen reaches out of his frame
to clink glasses with Ceauşescu (see Figure 3.4).[21] Afterward I was
told that many of the painters who had worked for Ceauşescu
had been compelled to change professions, but there is no sign
that the political art of that era is about to disappear. That auc-
tion and the ones that had preceded it sold out: mainly, it seems,
to Romanians.

Golub, Eisenman's reading of Cézanne, Hassam, Mitchell,
the anniversary canvas for Ceauşescu: my examples are meant
to indicate the enormous differences of opinion about the

21. Administration of State Patrimony and Protocol A.R., Auction of the Goods Previously
Belonging to Elena and Nicolae Ceauşescu (Bucharest: Sala Palatului, 1999). The where-
abouts of the painting are unknown.

relation between twentieth-century painting and politics. The disagreements are so wide and deep that it can almost be argued — as Eisenman has implied — that modernism is constituted by the disagreement.

If I persist in assembling writers as diverse as Kramer and Clark under the heading of social criticism, it is not because I want to demonstrate some unsuspected affinity between writers who are, I think, really at opposite ends of the artistic universe. It is because the emphasis on the politics of art, broadly construed, is a decisive one, and it can distinguish such interpretations from modernist and postmodernist ones. Fried put this well, and carefully, in the introduction to *Manet's Modernism*, in which he quoted a page of Greenberg's "Modernist Painting" and then, a page later, two long passages from Clark's *Painting of Modern Life*.[22] Greenberg's theory draws on a notion of the Enlightenment "critique of institutions," but Fried found it fundamentally an account of how modernist painting was "conducted in a void" outside of social developments. Fried contrasted Greenberg's "relative indifference" to subject matter to "the social historians of art," who "understand the emergence of modernist painting in Paris in the 1860s and 1870s as responding to a distinctive experience of modernity." Here Fried is somewhere between Greenberg and Clark: Fried remarked on the "void" in Greenberg's account and

22. Fried, *Manet's Modernism: Or, the Face of Painting in the 1860s* (Chicago: University of Chicago Press, 1996), 13–16.

said it is "open to serious objection," but on the other hand he implied there is some distance between himself and "the social historians of art."

The first passage of Clark's *Painting of Modern Life* that Fried quoted stressed Manet's interest in "those markers in the picture of where the illusion almost ended." Modernist painters, Clark said, were impressed not by the way earlier painters showed evidence of the "gaps and perplexities inherent in their own procedures" but by "the evidence of palpable and frank inconsistency." In other words modernist painters were drawn to the "material means by which illusion and likeness were made."[23] Fried posed Clark's text against Greenberg's by commenting, "Whereas Greenberg portrays the modernist artist as seeking a narrow certainty, Clark goes so far as to imagine a taste for uncertainty becoming almost an esthetic in its own right. But as Clark is aware, his conception of modernism is not simply or wholly opposed to Greenberg's."[24] This is an interesting way of putting the difference between these two passages, because Fried declined to identify his own position on the matter and because a reader might want to say that Clark is quite close to Greenberg here, except that Clark prefers to see the value accorded to the places where illusion is rescued against pictorial "chaos" in a less optimistic light.

23. Quoted in ibid., 15, from Clark, *The Painting of Modern Life: Paris in the Art of Manet and His Followers* (New York: Knopf, 1985), 10.
24. Fried, *Manet's Modernism*, 15.

Next Fried changed tack; the crucial difference, he said, is that although Clark recognizes the importance of flatness for Manet and his generation, Clark "refuses to hypostatize flatness" — instead he asks why flatness was a compelling subject at the time. According to Clark, flatness always "stood for something": "the Popular," "modernity," "the evenness of seeing itself" (as in Cézanne), or even "the simple fact of Art, from which other meanings were excluded." That last possibility makes for a wonderful comparison with Greenberg, because it almost is Greenberg's position, but with a tiny obdurate difference: "flatness in its heyday was these various meanings and valuations."[25] It is a fascinating and difficult difference, as close to identity as a concerted disagreement can be. It clearly names the conceptual gap between Greenbergian modernism (in which flatness exists as a property of the medium, aside from social developments) and social art history (in which flatness is its contextual meanings).

Fried's comment on this passage just makes the distinction between Greenberg's modernism and social art history that much more subtle. "This is superb in its way," he wrote, "and I have no argument with it. Or rather I have no argument with it as it applies to modernist painters after Manet." Flatness, Fried said, was not a leading term in the criticism until impressionism in the mid-1870s. I call this subtle because it does not address the other disagreement between Greenberg and Clark, over the

25. Quoted in ibid., 16, from Clark, *Painting of Modern Life*, 12, 13.

use of flatness as an ultimate term of explanation. In the end — when each text is read with full attention to the kinds of questions it asks and the answers it makes possible — these are not compatible versions of history or criticism. The society that surrounds the artwork exists in three forms in the three texts. In the passage from Greenberg's "Modernist Painting," the politics and philosophy of the Enlightenment are just the backdrop for a theory that ends up being "conducted in a void." In the first passage from Clark's book, social art history is a matter of rearranging Greenberg's terms, but in the second passage social art history poses a serious rejoinder to Greenberg's void. In Fried's interpolated comments, social contexts are at first things other historians pay attention to ("in contrast, the social historians of art understand the emergence of modernist painting") and then facts that require only small adjustments ("I have no argument" with Clark's position "as it applies to modernist painters after Manet"). This is not, if it needs to be said, a contradiction in Fried's account. It is a way of not introducing an unnecessary problem — the problem of the void — into a discussion of Manet, but in doing so Fried deliberately does not solve the disjunction between the approaches he cites.

Senses of twentieth-century painting that depend on politics do not add to a sequence of crucial and marginal movements, in the way that *October*-style postmodernism privileges surrealism and postminimalism. Kramer's century of painting began on a promising note with late Cézanne and continued through

abstract expressionism, but then it petered out.[26] Little was left of the second half of the century but odds and ends, mainly of contemporary figurative painting. I have mentioned some of the painters Crow has written about: generally speaking they have contributed to the lineages of conceptual and postminimal art. It remains an open question whether the writers associated with the third sense of politics (that it infuses and enables all art practice) have contributed to a distinctive sense of the century's most important moments. Foster and Buchloh, for example, tend to focus on work in a variety of media since the 1960s, and so their contribution to a picture of the twentieth century as a whole remains unfocused.

It is not possible to do any justice to Clark's choices in this format, but it is notable that *Farewell to an Idea* lingers on El Lissitzky (1890–1941), Malevich (1878–1935), and war communism in Vitebsk in 1920. It was a rare moment when the esotericism of modernism seemed "really to duplicate that of the people in power" — a brief moment when painting stood its best chance of working in the world.[27] It failed spectacularly. My moral is just that social art history and moral criticism do not lead to any unified sense of the peaks and abysses of twentieth-century painting but set themselves apart, by increments but decisively, from modernist and postmodernist conclusions.

26. Kramer, "Does Abstract Art Have a Future?" *The New Criterion* 21, no. 4 (2002).
27. Clark, *Farewell to an Idea*, 237.

4. The Importance of Skill

The notion that quality in painting is principally dependent on the painter's skill (or talent, if it is considered innate) is the most widespread of all models in the past hundred years. It is a cliché in the popular press: "Imagination without skill gives us contemporary art," as Tom Stoppard put it.[1] The voices of academic art history are faint beside the many writers who base their sense of history and quality on the painter's technical ability. Few people outside academia could make much, I think, of T.J. Clark's rejoinder that "technique in modernism is a kind of shame: something that asserts itself as the truth of picturing, but always against picturing's best and most desperate efforts."[2]

The most visible spokesman for this theory in the United States is not even an art critic: he is Tom Wolfe, novelist and author of what he described as "the one sociological study" of the American art world, the book *The Painted Word*. In Wolfe's view the American art world is "scarcely a world": it amounts

1. Tom Stoppard, "Artist Descending a Staircase," as quoted by Wolfe, "The Artist the Art World Couldn't See," *New York Times Magazine*, January 2, 2000, 16–19, quotation on p. 18.
2. T.J. Clark, *Farewell to an Idea* (New Haven, CT: Yale University Press, 1999), 48.

to just three thousand "curators, dealers, collectors, scholars, critics, and artists in New York." In January 2000, Wolfe wrote a sympathetic account of the American sculptor Frederick Hart (1945–1999), best known for *Three Soldiers*, a sculptural group that is positioned as a response to Maya Lin's Vietnam Veteran's Memorial in Washington, D.C. Wolfe compared Hart to Giotto and excoriated the snobbish art world for failing to recognize him. He described Hart's "bafflement" on encountering the art world's notion of skill. From the art world's point of view, artists such as Hart "used a devious means — skill — to fool the eye into believing that bronze or stone had turned into human flesh. Therefore, they were artificial, false, meretricious. By 1982, no ambitious artist was going to display skill, even if he had it." Wolfe said "art worldlings" disparage skill and look to works, such as Lin's, that are "absolutely skillproof."[3]

The defense of skill or technical ability often entails the defense of popular taste and of profit. Wolfe noted that Hart's acrylic castings brought in more than $100 million, but "none were ever reviewed," except in "so-called civic reviews," which he defined as "the sort of news or feature items or picture captions that say, in effect, 'This thing is big, and it's outdoors, and you may see it on the way to work, so we should probably tell you what it is.' " It is a pity that Wolfe's rhetoric is so blustery, because it would be interesting to see what a defense of skill would look like if it did

3. Tom Wolfe, *The Painted Word* (New York: Farrar, Straus and Giroux, 1975); quotation from Wolfe, "The Artist the Art World Couldn't See," 18–19.

not depend on appeals to popularity or market values. It might be difficult to defend skill in Wolfe's terms, because it would be clear that the modernist abandonment of skill grew organically out of the gradual erosion of realism. Sculptors such as Hart, whose work depends on Canova and Bernini, would then appear more clearly to have missed the point of realism's dead end. (It would also be difficult to defend popularity and profit without mentioning skill, because it would entail noticing other qualities of artworks that Hart shares with successful contemporaries such as Richard Serra and Anthony Caro, two sculptors Wolfe ridiculed.)

The defense of skill is also frequently millenarian. Wolfe praised Hart's "derrière-garde art" and saw signs of its resurgence in the emerging art of the third millennium. He cited the "sudden serious consideration" of Norman Rockwell (1894–1978), and he mentioned a sellout show of work mostly by graduates of the New York Academy of Art ("America's only Classical, derrière-garde art school"). Young collectors, he said, go for " 'pleasant' and often figurative art instead of abstract, distorted, or 'wounded' art of the Modern tradition," as is proved by the "soaring interest" in French *fin de siècle* academic artists such as William-Adolphe Bouguereau (1825–1905; see Figure 4.1), Jean-Louis-Ernest Meissonnier (1815–1891), and Jean-Léon Gérôme (1824–1904).[4]

4. Wolfe, "The Artist the Art World Couldn't See," 19. The sellout show was Norman Rockwell (New York: Hirschl and Adler Gallery [c. 1999]), and another popular show in the same year was Maureen Hart Hennessey and Anne Knutson, eds., *Norman Rockwell: Pictures for the American People* (Atlanta, GA: High Museum of Art, 1999).

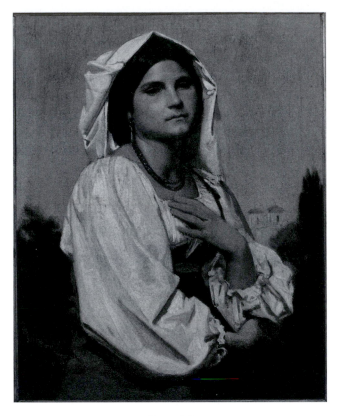

Figure 4.1

In the *New York Times* there is a distinction to be made between the Friday arts section, which is under the direction of Michael Kimmelman, and the various arts features that run on other weekdays or in the *Sunday Magazine*, which are less aligned with the art world and more likely to be conservative and antimodernist. Earlier in 1999 the *New York Times* had run a piece written by the journalist Deborah Solomon called "How to Succeed in Art," chronicling careerism among students in several Los Angeles art schools. The essay made fun of students who

refused to be interviewed by the *New York Times* because it would hurt their fledgling reputations if their gallerists found out they were still students.[5] Solomon interviewed several of the "power art faculty" at the University of California at Los Angeles, including Chris Burden (b. 1946), whom she reported as making $102,000 per year, and Mary Kelly (b. 1941), whom she quoted as saying "theory can make you a better artist." "One wonders," Solomon wrote, "whether the new-genre art favored in the 90's, the videos and installations, will ever be able to compete with the epic achievements of this century, the oil-on-canvas masterpieces done by modernists who may have mocked academic values but who made sure they knew how to draw."[6] The pattern, even in the *New York Times*, is consistent. According to another article by Solomon, Philippe de Montebello, director of the Metropolitan Museum of Art, said that one of Kiki Smith's (b. 1954) sculptures was "disgusting and devoid of any craft or aesthetic merit."[7] (The word craft was chosen perhaps because it sounds like it's a bit lower than technical skill.)

It is a sign of just how deeply academia and the art world are divided from the rest of the public that it has been necessary for me to cite newspaper articles as the principal theoretical sources for the defense of skill. Commercial art magazines such as *American Artist*,

5. Deborah Solomon, "How to Succeed in Art," *New York Times Sunday Magazine*, June 27, 1999, 38–41.
6. Ibid., 41.
7. Deborah Solomon, "Is the Met Phobic about Contemporary Art?" *New York Times*, January 9, 2000, 47.

The Artist's Magazine, TIEM Design (which gives Photoshop tuto-
rials in a relentlessly commercial naturalistic style), and *Airbrush
Technique* focus on technical advances and tips for naturalistic
painting but are less likely to contain polemics and apologias for
artistic skill.[8] Some artists' organizations have charters and position
papers; the Art Renewal Center announces itself as an organiza-
tion dedicated to the renewal of skill along with "training, stan-
dards, and excellence" in the arts. Their Web site features mainly
nineteenth-century-style paintings, but it also offers "responsible
views opposing those of the current art establishment" and a list
of forty-odd approved schools and teachers.[9] (Tom Wolfe should
see this list: it gives the impression that half the world paints in an
academic figurative style.)

Even farther afield are the "starving artist" sales that take place
in suburban Hiltons and Holiday Inns. I have had some contact
with the people who are the intended market for those venues.
When I was a graduate student, I supported myself in part by
teaching introductory art history in small colleges. That is where
I first encountered people who are impatient with modernist paint-
ing because it seems to lack skill. Students majoring in business,
telecommunication, premed, prenursing, and economics — in
other words, people not in the humanities or the sciences — asked
me to defend the art I was discussing by describing the skill that

8. http://www.tiemdesign.com/HOWTO/Photoshop.htm, accessed March 8, 2005.
9. http://www.artrenewal.org, accessed April 18, 2003.

went into it or, failing that, by citing its market value. In the art world the complaint "My six-year-old could paint that!" is a part of the history of modernism, and it is taken as an index to a certain kind of public incomprehension. But outside the art world it is a common complaint, and it is taken to be a sufficient rejoinder to the insult of what is taken to be intentionally incomprehensible art. Even so, the anonymous artworks featured in actual starving artist venues are not tremendously skilled by academic standards, and defending them would also require an appeal to their senti-mentality. Mass-production oil painting companies such as Art Liquidation also feature modern paintings that are not so much skilled as sweet or inoffensive (see Figure 4.2). It also matters that the paintings are not expensive: their cheapness is a signal that the makers are not part of the art world. Skill is the central criterion, but it is linked to sentiment, nostalgia, and conservatism.

I also encounter that larger public in the galleries of the Art Institute in Chicago, where I teach a class in which students set up easels and copy paintings. Visitors naturally listen in, and some mistake me for a public demonstrator and ask questions. From those conversations I have become aware of a point of view in which all old masters are more or less interchangeable, and all of modern art is considered a lesser achievement. I have seen people literally rushing to get through the modern galleries, and I have been asked if modern painting is not really all about money or greed. One notion that seems to be widely held is that good painting basically ended with Rembrandt. (I suspect the

"Modern Paintings" from the Art-Liquidation.com website (April 2003)

Test at the side:
"The following paintings are in stock.
These are the actual photos of the paintings."

Top left:
 Modern Oil painting on canvas
 Item # 391
 Size:8x10 inches
 Price: $19.
 Condition: New
 Signed: No
 Stretched: Yes

Above:
Modern Oil painting on canvas
Item # 390
Size:8x10 inches
Price: $19.
Condition: New
Signed: No
Stretched: Yes

Left:
Modern Oil painting on canvas
Item # 389
Size:8x10 inches
Price: $19.
Condition: New
Signed: No
Stretched: Yes

Figure 4.2

reason people think so is that Rembrandt is the most recent old master whose name is widely known.)

In my experience a person who judges painting primarily by skill is not just saying that an artist should be able to render convincing fabrics or faces. Rather the judgment means that painting should be a fully immersive experience: it should let us forget ourselves for a while, and wander, in imagination, through

the painted scenes. A lack of skill means that the painter is not able to capture viewers in that way. There are a number of contemporary painting practices that can be fully immersive: fantasy art, painted backdrops in Hollywood films and in Universal Studio-type theme rides, digital video games, commercial portraiture, and landscape painting. Modernism, with its references to itself and its physical materials, fails to immerse its viewers in that way.[10]

The mix of skill, immersive experience, and sentiment is exemplified in another essay by Solomon, called "In Praise of Bad Art"; it concerns the *fin de siècle* revival of interest in Norman Rockwell, Victorian fairy painting, Walt Disney cartoons, N.C. Wyeth (1882–1945), and nineteenth-century painters including Bouguereau and Moreau.[11] Solomon said the distinction between high art and low art is entirely gone, and viewers are now free to openly enjoy what had been only guilty pleasures. The situation has changed, she claimed, since Susan Sontag wrote her "Notes on 'Camp' " in 1964. Rockwell's fans no longer think of him as campy; they "see him as a gifted artist snubbed by modernist taste." Now that the "once-forbidden line separating high and low culture" has been erased, it is not necessary to look

10. I use the word immersion to avoid implying that Fried's sense of absorption can be unproblematically extended to this kind of experience. The thematic is related, but the kind of immersion I am describing here requires a different sense of what painting is, and a widely divergent understanding of how the history of painting might be relevant to its current practice.

11. Deborah Solomon, "In Praise of Bad Art," *New York Times Magazine*, January 24, 1999, 32–35.

at Rockwell with irony or knowing detachment. Rockwell, "Mr. Sentimentality, is the perfect symbol of our times." There is a bit of irony in that sentence, but most of Solomon's essay is against irony, and also against the "snobbery of the past," when high-art priests oppressed people with their "aridness and pretense." Now, at last, mass culture has become culture, and the levitical caste has been expelled. The avant-garde has ceased to exist, or has changed its name and gone underground, masquerading as the new populism.

Solomon's essay speaks for a large public of museum visitors and collectors, and also for a significant portion of the art community, where high art and low art are considered a thing of the past, and where a velvet painting of Elvis might command as much attention as the latest Sherrie Levine. It is a stance made possible by a carelessness about the ways that historical judgments might continue to bear on the present. And indeed history came creeping back in, when Solomon touched on the problem of distinguishing good bad art, the kind she said is celebrated, from bad bad art. She quoted Robert Rosenblum, who told her that he agrees with something once said by François Cachin, former director of the Musée d'Orsay (a museum devoted in large part to "bad" academic nineteenth-century painting, including Bouguereau and Moreau). Cachin said "Oh, but I only like the best bad art!"[12] What would that be, exactly? At first Solomon

12. Ibid., 32.

said it is "not amateur painting" but "technically skillful" art. It is also painting that is openly sentimental, with "no angst, no alienation" — painting infused with nostalgia, even "supercornball" painting such as Rockwell's. I wonder where the line might be drawn on sentimentality. Would Solomon accept Joseph Csatari (b. 1926), whose paintings make Rockwell's look sour? Csatari was a friend of Rockwell's, and he inherited his position as official painter for the Boy Scouts of America in 1977.[13] His work is as skillful as Rockwell's, but his sentiment is stronger: is that on the edge of bad bad painting? (The ironies of the situation are somewhat alarming: in Solomon's expression "bad bad painting," the second "bad" is in invisible scare quotes, because the art is not bad now that the revaluation of values has put it on a par with all painting. But what is to prevent the first "bad" from having its own set of invisible scare quotes? Would Solomon want to defend "bad" "bad" art?)

The sequence of twentieth-century painting implied by the valuation of skill and immersive experience does not include cubism, which might be considered skilled (although I am not aware of any such claim) but rejects an immersive encounter. The sequence includes, nominally, *fin de siècle* work such as Franz von Stuck's (1862–1928); photograph-like surrealism, including the works of René Magritte (1898–1967), Paul Delvaux (1897–1994), Max Ernst (1891–1976), Leonora Carrington

13. http://www.csatari.com/index.html.

(b. 1917), Leonor Fini (1908–1996), and Dorothea Tanning (b. 1910); social realist and even socialist realist painting from around the world, but especially including the works of Rockwell Kent (1882–1971) and Norman Rockwell; and a miscellany of contemporaries who exhibit painterly skill, such as Lucian Freud (b. 1922), Odd Nerdrum, Komar and Melamid, and John Currin (b. 1962). Some op art is also included, especially in South America where Victor Vasarely (1908–1997) is considered an important painter. Most of the painters who have been praised for their skill are not known in the art world but represented by commercial galleries in places such as West Hollywood and Beverly Hills, Sausalito, the Île de France, Naples and Boca Raton in Florida, Fifth Avenue in Manhattan, and Michigan Avenue in Chicago.[14] It is an odd canon, omitting as it does so much of the century, from international abstraction to abstract expressionism, art informe, most of pop, color field, minimalism, and postminimalism.

It can seem that in the context of modernism or postmodernism, judging a painting by its maker's skill is ideologically overdetermined and therefore necessarily irrelevant. On the other hand, it can be argued that a lack of specific kinds of technical skill affected the work of some major twentieth-century painters, and that argument can open the way to a reintroduction of the question of skill. I agree with John Golding's argument that Duchamp's helplessness in the face of ordinary life drawing prompted him to find the mechanical shapes he ended

up using in the *Large Glass*.[15] In Duchamp's case a lack of control over the painted body was a cause not of failure but of success; the brittleness and unsteady articulation of his mechanomorphic figures after 1912 correspond exactly to the weaknesses of his earlier postimpressionist figures. Before and after the change, his figures are spindly and ill proportioned, with a tendency to tilt or slide instead of standing in proper *contrapposto*. They are unevenly executed, without an eye to the whole figure. It did not matter after the *Bride*, but there are marked weaknesses before: *Apropos of Little Sister* (1911), for instance, is a frail picture in which the weakness and hesitancy known to any beginning student are camouflaged — as any beginning student does — by atmosphere (see Figure 4.3). How to get that knee to wrap around the other, how to do a slumping back and neck, how to manage lips in profile; the problem points are disguised by the kinds of gaps permitted by cubism. Duchamp's lack of competence at academic figure painting has no bearing that I can see on his place in twentieth-century painting, but it does have specific effects on his mature manner.

The same type of argument can be made, I think, about a number of artists, including Robert Delaunay (1885–1941), Francis Picabia (1879–1953), Mark Rothko (1903–1970), and

14. See, for example, the list of Hollywood galleries at http://artscenecal.com/Listings/WestHwd/WestHwd.html; Sausalito art galleries at http://www.sausalitoartgalleries.com/; Naples art galleries at http://www.explorenaples.com/results.phtml?categories=ART%20GALLERIES; and Boca Raton art galleries at http://www.worldartantiques.com/FloridaBocaRaton.htm.
15. John Golding, *Marcel Duchamp: The Bride Stripped Bare by Her Bachelors, Even* (London: Allen Lane, 1973).

Figure 4.3

Jasper Johns (b. 1930). In each case the artist's development from academic figural work to the signature style closely follows flaws in his naturalism. Pierre Bonnard (1867–1947), for example, was at times incapable of rendering figural proportions and architectural perspective so that they were adequate to the level of naturalism the paintings otherwise posit. When his perspectival

lines do not converge well enough to present themselves as naturalistic, they give the paintings a kind of wavering flatness that can be understood only as a mismatch between the absorptive naturalism posited by the remainder of the painting and the inadequate support for that naturalism given by the perspective. (I have to put this in a roundabout way because the failures of his naturalistic skills only matter when they are balanced against what happens elsewhere in the paintings.) His figures sometimes combine well-rounded limbs with flattened ones, so that they seem unsure whether they should occupy the picture's volume or keep subservient to the painted surface. In a generous reading, the mismatch between naturalistic intimism and unnaturalistic depiction is an expressive trait, not a distraction and certainly not a problem. But the paintings continuously raise the question of the harmony between the different tools of naturalism.

Bonnard was aware of these issues, and he especially agonized over what he thought of as his deficient drawing. The relevance of his concerns can be gauged by comparing his naturalistic skills with those of followers who are less skilled in the same kinds of depictive problems; for example, Ettore Fico (b. 1917), an Italian painter who closely emulated Bonnard in the 1970s.[16] Fico's *Porta rossa: Omaggio a Reycend (1977)* is nearly a copy of the kitchen letting onto the garden in Bonnard's *Dining Room in the Country (1913)*: same open door, oblique view, flattened

16. Ettore Fico, opere 1964–1989 (Torino: Fabbri, 1989).

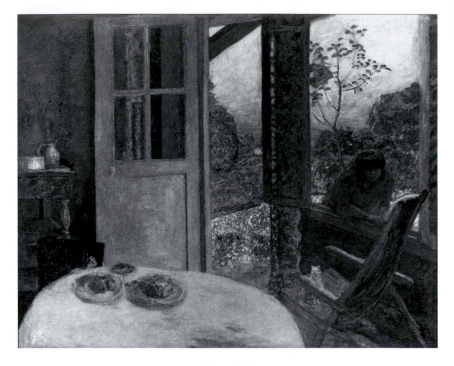

Figure 4.4

Cézanne-style kitchen table, phosphorescently tinted garden (see Figures 4.4 and 4.5). Fico was more constrained than Bonnard by a lack of skill. Here, he keeps his vertical lines strictly vertical, giving his painting a schematic look but avoiding the uncertainties of Bonnard's lines. Aside from such points of stability, Fico is hopeless, and his weakly imagined garden shows how Bonnard's organic shapes are woven into his architectural forms. Fico can barely paint his way from the step out to the shrubbery, mainly because he seems to be thinking of real, Euclidean space and not letting Bonnard's organic, wavering sense of space help his painting's architecture cohere with its organic forms. The place

Figure 4.5

of Bonnard in twentieth-century painting is a fascinating question, shared by a number of art historians who find themselves attracted to his work.[17] I do not pursue it here except to say that Bonnard's control and his level of academic skill — in particular his sense of drawing — have to figure in any answer.

Another example of a painter who can be considered in terms of deficient technique is René Magritte. In the 1920s he was painting figures in a style reminiscent of contemporary advertising and movies. The men in *The Menaced Assassin (1926)* wear eyeliner, adopt blank expressions, and strike mannequin poses (see Figure 4.6). His technique here is only a half step behind his chosen style. He had trouble with three-dimensional objects: the trumpet of the Victrola looks a bit soft; he was not sure how to cast oblique light onto a face (the shadows are weak and formulaic, like a beginning student's would be); he diffused one shadow as it moves across the floor (another student's trick to ensure the floor seems flat); and he made the receding walls get suddenly darker at the back (a simple trick that keeps a room in perspective when it would otherwise look collapsed). In later paintings it can appear as if Magritte had only recently discovered how to represent the objects and that his criterion of naturalism is just that the objects should permit a viewer to

17. Timothy Hyman, author of *Bonnard* (London: Thames and Hudson, 1998), told me that "part of the reason for my feeling impelled to write about Bonnard, was … the failure, among the people I knew, from my years at the Slade in the mid-sixties right through to the eighties, to place Bonnard within the canon"; letter to the author, January 5, 2000.

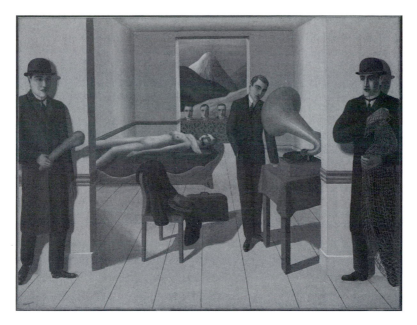

Figure 4.6

suspend disbelief — provided the viewer does not start looking too closely and actually enjoying the illusion, as viewers tend to do with naturalistic paintings. Magritte learned to paint birds through a series of discrete stages, and it seems he put each new skill to work as soon as he found it: the dead bird, painted as a lump or with wings outspread in the curled "V" ubiquitous in children's drawings; then later, birds in sitting poses; and finally birds whose feathers have visible shanks and quills. He found a rudimentary way to paint steam and smoke, and used it without change in works leading up to *Time Transfixed (1938)*, in which a steam locomotive comes out of a fireplace. His faux-wood grains and faux marble in that painting are poor by the standards

of professional faux-texture painters, but they do what Magritte wanted them to: they signal a willing observer not to look more closely than necessary. None of this, I repeat, argues against Magritte's place in histories of twentieth-century painting, but I think that attending to skill in this very straightforward manner — not as an ideology but as a technical matter — makes it difficult to think of Magritte's paintings as they are presented in the academic literature; that is, as primarily conceptual exercises that put *trompe l'oeil* to unexpected uses.

There are many other possible examples. André Masson (1896–1987) is an artist whose work was hobbled at times by his inability to connect the limbs of a figure, to attach a hip to a torso, or to see how to create the roundness of a cheek. Even within the boundaries of the outline manner he adopted in the mid-1920s, it is possible to locate choices forced on him by limitations in his ability to negotiate the outlines of three-dimensional forms. *Battle of Fishes (1926)* has gaps and infelicities that could have been patched without undermining the sense of automatism. Gaston Chaissac (1904–1964), once called "Picasso with wooden shoes," made works that I find impossible to see without wondering what they might have been if he had been able to draw competently by academic standards.[18] The German artist Ernst Matthes (1878–1918), who lived in Paris, pointed up how Toulouse-Lautrec depended on his own

18. Barbara Nathan-Neher, *Gaston Chaissac* (Stuttgart: Klett-Kotta, 1987); Angelika Affentranger-Kirchrath et al., eds., *Gaston Chaissac 1910–1964* (Stuttgart: G. Hatje, 1996).

Figure 4.7

facility (see Figure 4.7). Some of Matthes's paintings took the same subjects as Toulouse-Lautrec's, but Matthes presented them without any flair — his lines do not swirl from one figure to another as Toulouse-Lautrec's do, and his figures seem heavy and motionless. When the representational going got tough, Matthes let his outlines fade into a fog, and he was content to depict bodies as ovals and limbs as sticks. It is as if his figures were tamped down, or rounded off, by his encounter with Munch.[19]

And last, although I have been talking about limitations of skills, modernism also involves academic representational skill

19. Maurice Denis was another influence. See Ernst Pöppel, ed., *Ernst Matthes 1878–1918* (Bremen: Kunsthalle, 1972), 12.

and the immersive experiences that they have been taken to enable. This is a subject too large to be usefully summarized, but instances of it include De Kooning's problematic facility and his laying down of skill in drawings done with his eyes closed; Mondrian's flower paintings and their relation to his signature technique; Nolde's early architectural watercolors and their role in his antiacademic style; Rothko's wavering figural style and its relation to the indistinct boundaries of the mature paintings; and even Kosuth's skills at lettering, wall paintings, and stenciling. These are just tokens of arguments that might be joined without leaving either the discourse of modernism or the nonacademic discourse of traditional painterly technique. Each of them has been hinted at in the scholarly literature: what is missing, from the point of view of a person for whom painting aims at an immersive experience enabled by the painter's academic abilities, is a detailed consideration of specific talents and abilities, and the specific expressive reasons artists had for trying to put them aside. Exactly how is Nolde's wildness — his sense of what is expressive — a product of his particular skills at rendering the linear forms of furniture with nearly myopic precision? A question such as that asks for an inch-by-inch understanding of skill, one that would be recognizable to viewers for whom realism counts as more than a convention among many — and at the same time the question is open to the historical study of expressionism because it can be answered using historically specific senses of terms such as expression, skill, rendering, and realism.

I mention these examples not to defend the sense of skill advocated by Wolfe or Solomon but to suggest that their position and the academic disregard of skill are partial accounts. Serious discussions of the place of academic rendering are absent in the popular press, where the defense of skill is done without taking modernism into account, and also in academic art history, where the embargo on the discussion of skill as anything except a historically delimited practice prevents certain questions from being asked about figurative and nonfigurative art. Skill can often be a matter of shame in modernist theory, but it is also shamed by modernist theory: and accounts that privilege skill tend to feel modernist criteria, if they feel them at all, as a kind of shame. The mutual misunderstanding is a deep and interesting challenge for accounts that would speak about painting more widely.

5. The Idea That None of This Matters Anymore

As Giacometti said, "Que ça rate, que ça réussisse, après tout, c'est secondaire" (It's unimportant, in the end, whether a work succeeds or fails). I would be surprised if Giacometti believed that, or wanted it to be taken literally: the maxim works, I would like to think, as a spell, ensuring the insouciance that he needed when the quality of art was put so continuously into question. I would read the line differently if it had been said by Warhol, because then it might be a slap at the outmoded values of fine-art pundits. There are various ways to claim that the history of painting from 1900 to 2000 has no hierarchies or high points apart from the contexts that made them appear so, or alternately that the ways I have been describing hierarchies and high points are not sensible or relevant. I will mention three ways: visual studies, newspaper art criticism, and historiographic studies in art history.

The most interesting, and probably the most influential, way is exemplified by the new field of visual studies. The

pluralism of visual studies is founded on the denial that dif-
ferences between high art and low art are a relevant starting
place or reference point for interpretation, or on the more
drastic claim that high art and low art have become mixed and
are effectively inseparable. The revaluation or rejection of the
modernist distinction between high art and low art creates a
relativized field of art in which the act of privileging one work
over another cannot be justified by appealing to values that are
taken to be normative. The resulting relativism is compounded
by the pluralism of the contemporary art world, which discour-
ages extended comparisons between different works by making
all comparisons seem somehow misguided. (I say "somehow"
because the pluralism of the contemporary art world tends
not to be theorized. If it were, it would become apparent that
comparisons are made continuously and cannot be abandoned
without abandoning the sense of current practices.) The result,
in visual studies, is a lack of interest in problems of the kind
I have been addressing. The senses of history given us by mod-
ernisms and postmodernisms would have to appear misguided
(because relativism or pluralism renders them naive) and old-
fashioned (because art and history have moved on). This book,
I imagine, would appear conservative or nostalgic, as if I were
hoping to revive one of these accounts to energize current
art practices. (I hope it is clear I have no such intention: my
interest is to understand past judgments and to find how the
twentieth century has been understood.)

An initial problem with the positionless position of visual studies is the persistence of the avant-garde. The mix of subjects in visual studies programs includes Disneyland, advertising, television, Hollywood and Bollywood, and many things that were once not part of academic study, but it also includes contemporary avant-garde art. Scholars who identify themselves with visual studies or visual culture write about all kinds of visual practices but also about contemporary video, performance, Internet art, photography, and painting. The proportions of popular and avant-garde art in visual studies do not reflect the actual numbers of those kinds of image-making, betraying a special interest in the art world and a lingering sense that the avant-garde is distinct from popular culture. Truly pluralist or relativist visual studies would take just as much interest in companies that produce metal tags for industrial use, as in Damien Hirst's metal sculpture.[1]

The same phenomenon of the lingering avant-garde can be observed in newspaper art criticism. Deborah Solomon said that even that most annoying and problematic avant-garde work, Duchamp's *Fountain*, now "looks classical." From Solomon's point of view, there really is not an avant-garde anymore, because bad art and fine art can be appreciated equally. Yet the avant-garde is present in her essay, in the form of Jeff Koons

1. These two paragraphs summarize arguments in my *Visual Studies: A Skeptical Introduction* (New York: Routledge, 2003).

(b. 1955). She called his work a "numbing experience," betraying her annoyance that everything has not quite become "classical" and that the avant-garde still has the power to prod.[2] When she asked how we might get away from Koons, she used words and ideas right out of the high modernist avant-garde: "Where can we go," she asked, "to find the edge, to recover our lost wildness, to escape the thronged blockbusters?" Those antipopulist images are a letter-perfect description of the very avant-garde she thinks has vanished.

Solomon exemplifies a kind of thinking whose roots can be traced to pop art. In generalized form the claim would be something like this. The four theories I have set out here might be true within the limits of their assumptions about twentieth-century art history and painting, but the problems they raise are no longer pertinent. It might once have been important (so the rejoinder might go) to make choices among such theories, or to worry about the shape of twentieth-century painting as a whole, but such questions are moot because high art and low art are thoroughly mixed. The twentieth century was rich in miscellaneous practices, from Mondrian to cigarette ads, and there is no longer good reason to make artificial distinctions between fine art and popular images.

Visual studies and popular arts journalism are two sources of relativism or pluralism that can make it seem inadvisable to

2. Deborah Solomon, "In Praise of Bad Art," *New York Times Magazine*, January 24, 1999, 24.

study large-scale accounts such as those I have been describing. Historiography is a third source. For some historians, modernisms and other accounts are best explained by their particular historical contexts and their associated politics, making an enterprise such as this one seem, again, naive. The idea would be that Gombrich's theories, for example, are explained by considering his education, ideas, and milieu. Such scholarship is historiographic and forms an indispensable part of the self-awareness of art history. I am not following it in this book for the simple reason that I am interested in the Nachleben of these ideas: their survival into the present and their capacity to order and direct the ways we can perceive twentieth-century art.

From a historiographic perspective, the high-low division is a claim about canons. It is about the ways certain people used judgment to buttress ideas about art, and it depends on constructed notions about skill, class, the importance of canons, and the European heritage. It was never an objective judgment and even the examples of skill I have described in this book are firmly based on very specific representational and illusionistic games. It is therefore (as the historiographic perspective would have it) not entirely sensible to chronicle ideas that depend on constructions such as the high-low difference as if they had truth content: to critique them, if a critique were necessary, it would be enough to investigate and reveal the historical contexts that gave rise to them, and the conditions of discourse that made it possible to believe they were true.

My general response to these three kinds of objections (the one I am associating with visual studies, with arts journalism, and with historiography) is that they confound ways of talking that allow a certain sense of culture to go forward with the project of understanding the past. The force of visual studies and of populist claims such as Solomon's is pragmatic: they clear the way to enjoy, consume, and study a fuller range of visual production. That can make excellent sense, but it is not a theory about the past, and nothing except the joy of the moment warrants the conclusion that the force of past judgments and values is now vitiated.

Historiography is the symmetrical and opposite case, because it recovers ideas held in the past, but it can miss the ongoing significance of those ideas for the present. It is not enough to say that past ideas are constructions, because the judgments made by earlier generations of historians and critics are not overturned by the awareness that their judgments pertain to certain times and places. Historiographic studies can decisively rework understandings of the past but do not affect the values that had been placed on art. To do that, scholars need to argue directly with past judgments and, ultimately, provide new ones that are more powerful and convincing. This book is intended as a first step in that process.

6. Conclusions

To my mind the four models of modernism, postmodernism, politics, and skill are the cleanest arrangement of the existing approaches to twentieth-century painting. I could have added or substituted many others. Peter Bürger's sense of modernism, for example, encompasses Dada and surrealism; its dynamic opposition between autonomy and politics is in places significantly different from any of the theories I have picked.[1] I have omitted some politically engaged theories such as Karl Werckmeister's, because it is not clear enough to me how they impinge on the canons of twentieth-century painting. Donald Kuspit's psychoanalytic criticism also implies a different shape to the twentieth century, one that privileges journeys of self-critique and renewal and cuts across movements and decades to assemble an idiosyncratic canon.[2] Jay Bernstein proposed an alternative to Clark's account in which the materiality of the sign is "soldered repeatedly to the social" rather

1. Peter Bürger, *Theory of the Avant-Garde*, trans. Michael Shaw (Minneapolis: University of Minnesota Press, 1984).
2. For Donald Kuspit, see (among many others) *The Critic Is Artist: The Intentionality of Art* (Ann Arbor, MI: UMI Research Press, 1984).

than set against it as a "contradiction."[3] Adorno's *Aesthetic Theory*, preeminent among the theories I have not discussed, begins by naming 1910 as the pivot of modernism after which "nothing concerning art is self-evident any more." His evaluation of avant-garde art is implicit in several of the accounts I have mentioned, but I did not include him because the extension of his ideas beyond music, and beyond midcentury, is unclear.[4] Thomas McEvilley proposed a cyclic theory, in which skeptical periods related to postmodernism have supplanted rationalistic periods such as modernism several times since the Greeks. (Duchamp is McEvilley's candidate for the first appearance of the current postmodernism.)[5]

There are others. Ian Heywood's *Social Theories of Art* extends a line of theorizing about fine art from Hegel and Habermas through Bürger; Matei Calinescu proposed a "physiognomy" of modernism divided into five types; Ihab Hassan described a post-modernism divided into a dozen categories; and Karsten Harries's *Meaning of Modern Art* proposes philosophic analyses of major moments in modernism.[6] Each of these is a strong candidate for

3. Paraphrasing Jay Bernstein, "Social Signs and Natural Bodies," review of Clark's *Farewell to an Idea*, in *Radical Philosophy* 104 (December 2000): 25–38, paraphrasing p. 36. In my reading, Bernstein's reading at this point is one of Clark's acknowledged choices and not a place where something "goes wrong" in Clark's account. (The expression is Bernstein's; "Social Signs," 36.)
4. Adorno, *Aesthetic Theory*, vol. 88 of *History and Theory of Literature*, ed. Gretel Adorno and Rolf Tiedemann (Minneapolis: University of Minnesota Press, 1997), 1.
5. Thomas McEvilley, "The Art of Doubting," in *Sculpture in the Age of Doubt* (New York: Allworth, 1999), 3–30, especially pp. 26–29.
6. Ian Heywood, *Social Theories of Art: A Critique* (New York: New York University Press, 1997); Matei Calinescu, *Five Faces of Modernity: Modernism, Avant-garde, Decadence, Kitsch, Postmodernism* (Durham, NC: Duke University Press, 1987); Ihab Hassan, "Pluralism in Postmodern Perspective"; and Karsten Harries, *The Meaning of Modern Art: A Philosophical Interpretation* (Evanston, IL: Northwestern University Press, 1968).

a foundational theory of modernism or postmodernism, and I omitted them either because they are not primarily historical in orientation or because I have been unable to determine if they have had an effect on the wider community of artists and scholars. And because I am also surveying nonacademic writers, I will add that even L. Ron Hubbard, founder of scientology, has a theory of modernist art, even if it is a bit vague: the modernist painter has to be master of several styles, he claimed, but only to put each in the service of "emotional impact."[7]

I can expand the list of sources until it becomes an encyclopedia. I am interested in the possibility of rearranging the theories, and I expect that each historian would manage this material quite differently. At several points while I was writing this book I was tempted to rearrange things so that Adorno could take center stage. I also considered reframing the section on postmodernisms, either by choosing Fredric Jameson as a central example or else by starting with Hubert Damisch. Gender theory, including feminist art history, can be presented as potentially fundamental to each of the theories I have listed, forcing a revision of the entire listing — although as I argued at the beginning, such an account would have to show how the fundamental realignment of interpretation embodied in identity theory or gender theory has created senses of the past century's high points and low

7. He mentions Hubert Mathieu, a painter I have been unable to trace. L. Ron Hubbard, "Art, More About," in *Art and Philosophy of Art* (Los Angeles: Bridge, 1998), 52–57.

points that are different from the four I have proposed here.[8]
A strong psychoanalytic reading of modernism, such as Georges
Didi-Huberman's, would force a rearrangement of the idea of
chronologies and schools and might result in an entirely differ-
ent understanding of twentieth-century painting.[9] I am open to
many possibilities, but in relation to each of them I propose the
following hypothesis: the field of possibilities is narrower than
the wilderness of the literature might suggest. I would not mind
if the four are rewritten as five, as Calinescu has done, or shrunk
to the dyad avant-garde and kitsch, as Greenberg once did. What
matters is the low number: it is not 40 or 400, as it might well
have been given the enormous number of "isms" and artists.

It might seem that the root problem here is that all these
sources are from western Europe or North America. But I find
it is not the case that non-Western countries have produced
importantly different accounts that are waiting to be discovered.
What does exist outside North America and western Europe
are many texts that stress regional and national art and there-
fore appear partly or largely unfamiliar. Such texts can present
very different pictures of painting in the twentieth century: for
example, cubism is minimized in Chilean and Paraguayan texts,

8. But see especially Rozsica Parker and Griselda Pollock, *Old Mistresses: Women, Art, and
 Ideology* (London: Routledge Kegan Paul, 1981), which proposes new shapes for several
 centuries in art history. The date of that book — 1981 — could be taken as an indication
 that the aspiration to directly rewrite art history pertains to a moment in the history of the
 discipline that is now past.
9. Georges Didi-Huberman, *l'Image survivante: Historire de l'art et temps des fantômes selon Aby
 Warburg* (Paris: Minuit, 2002).

and *art informe* is emphasized in Scandinavian texts. It is possible to take such accounts as important alternates, and art history can only be enriched by doing so. But how many of them are different in underlying structure from the four basic models? In my experience researching texts written outside western Europe and North America, I have found that the altered narratives tend to be dependent on Western texts, so that their unfamiliar emphases and examples reduce to Western models.[10] Texts by Helen Gardner, Horst Janson, and E.H. Gombrich have been translated, adopted, and often pirated for use in many different languages and cultures. The most widely disseminated model for world art history, *Gardner's Art through the Ages*, is driven by a modernist sense of art history, enriched in later editions by contributions made by social art historians, and that dual emphasis remains when the text is translated and adapted.[11] There must be hundreds of thousands, perhaps even millions of people whose knowledge of art history is based on abridged or augmented versions of Gardner's book. Examples I have seen from India and China were done outside copyright law, and therefore also beyond the supervision of the original editors and publishers.

Even the many auction catalogs produced outside Europe and the United States depend on the framework provided by

10. Elkins, *Stories of Art* (New York and London: Routledge, 2002), 147–51, and passim.
11. Helen Gardner et al., *Gardner's Art through the Ages* (Fort Worth, TX: Harcourt College Publishers, 1996); the same applies to Marilyn Stokstad, *Art History* (New York: Harry N. Abrams, 1995) and many others.

texts such as Gardner's. The Christie's branches in Hong Kong, Singapore, Taipei, Melbourne, and Sydney, together with the Sotheby's in Hong Kong, produce a library of volumes each year. The prices they report depend on many factors, yet beneath them — often buried so deeply as to be nearly invisible — is the structure of art history as it is taught in southeast Asian schools, and that structure depends — often subtly but sometimes directly — on the basic theories I have outlined.

My hypothesis, then, is that interpretations of modernist painting derive largely from the four models I have outlined. They can account for the majority of the reasons why any given work or movement in twentieth-century painting is valued. To this working hypothesis I add a puzzle: Why aren't there dozens more theories of equal influence? Why is it that such a small number of models can capture the judgments that drive so many different practices? Why did a century so crowded with competing notions of painting end up generating such a small number of interpretations?

Several possibilities seem equally plausible. I am sometimes tempted to take the line Adorno adopted in relation to the avant-garde: that the best accounts come from a small number of people who take the field seriously, whereas the majority are content with received versions of history. Or it can be urged that art history does not depend on such models but works instead by encounters with individual objects, in which the particularities of the objects determine the path of the inquiries. In that

view, overarching theories of modernism or postmodernism have no grip on real-life experiences of painting. Both of these are plausible, but it is not my purpose here to explore them. What surprises me, and what I find significant for understanding the myriad judgments that have been applied to paintings in the past century, is that the wilderness of writing on twentieth-century painting is really an orderly place where the majority of judgments are received opinions, derived from a very small number of models.

Seminar

This conversation with James Elkins was recorded March 3, 2004, and edited March 22, 2004. The participants, all from University College Cork, were Francis Halsall, History of Art; Paul Hegarty, Department of French; Gert Hofmann, Department of German; Julia Jansen, Department of Philosophy; and Arpad Szakolczai, Department of Sociology.

FH: Why do you concentrate on painting?

JE: The most interesting historically informed discourse on modernism tends to center on painting, so the challenge in understanding the historical or critical values that have been accorded to other media is to see how they have been relocated from their places in the discourse on painting. The emerging discourses on individual media (and the general or totalizing discourse on media "itself") can be read as second-order phenomena, ones dependent — perhaps at several removes — on an identifiable original.[1]

1. For example, W.J.T. Mitchell's writing on media and the Chicago School of Media Theory initiative, www.chicagoschoolmediatheory.net/home.htm; also Rosalind Krauss's mediation on media, *Voyage on the North Sea: Art in the Age of the Post-Medium Condition* (London: Thames and Hudson, 2000).

FH: Although, in postmodernism, what comes up for grabs is painting itself. What is implicated in postmodern theoretical practice, for instance, in *Formless*, is the specificity of media. Postmodernism and painting, in some respects, are mutually exclusive.

JE: From my point of view, *Formless* is still fairly media specific, even though the concepts are not: their examples circle back to painting even when their "dictionary" ranges into places where painting, I assume, would not be taken to be able to follow. Certainly it is true that many postmodernisms are predicated on the dissolution of painting, but here I would take my cue from Stephen Melville, who has interesting things to say about how painting exists in a phantom fashion following minimalism: it has to learn — I am paraphrasing him — to "count."[2] Meaning that there can no longer be much sense to the idea of an individual painting that stands for the sum total of whatever painting can be at a given historical moment. The concept of the multiple, therefore, has to be taken onboard as part of a fundamental rethinking of painting that nevertheless does not occur separately from concepts of painting. Melville's account, as I read it, is compatible with T.J. Clark's sense of "contingency," meaning at least that painting has to

2. Phillip Armstrong, Stephen Melville, and Laura Lisbon, eds., *As Painting: Division and Displacement* (Cambridge, MA: MIT Press, 2001).

consider itself in continuous need of reinvention, in a more radical sense than Clark intended when he was writing about contingency in the *Death of Marat*. In this particular sense what orients the magnetic field of painting, what supplies its Magnetic North, is still what used to be called painting, no matter how distant, abstract, or attenuated it seems.

FH: What seems to me to be important in postmodernity is that in modernism's own terms, it cannot go beyond Louis or Stella: after that, what happens is beyond painting. The most significant things that happen in postmodernity are no longer concerned with painting. If we see Polke as the most important moment in current art, we end up with an uneasy relation to tradition.

JE: If you're talking about modernism in Greenberg and all that, then I have to agree because modernism defines itself as a closed system. This would be one of the places where the project I am exemplifying with *Formless* would have something at stake. But the discourse of modernism can be altered in such a way that what appears to be a wholly different way of talking — a postmodernist way — becomes unintelligible without the discourse of painting.

PH: Couldn't it be seen the other way around? If modernism is over for painting, then that is exactly where you look for postmodernism: in rubbishy kitsch painting, painting

that knows it shouldn't be doing painting. The fact that
no one has done modernism in, say, video, means they are
still rummaging around in very dated bits of modernism.
Maybe the "overness" of something, the "you shouldn't be
doing this," makes it more interesting. There is less striv-
ing, more "there you go."

JE: It is certainly much easier to make an acceptable piece
of video art than it is to make an acceptable painting,
and if you put on your Greenberg hat, the reason for the
relative ease of video art is that painting has a longer his-
tory: more strictures, more limitations, fewer possibili-
ties, a much denser lexicon of critical terms. Therefore
— to make this a little more serious — if you're talking
about a historical discourse, which is what is at stake
here, the ease of video is a reason to keep considering
painting especially when it's a place where things seem
to keep going wrong, or where the artists are deliber-
ately misbehaving themselves, piling kitsch on camp on
kitsch without end.

FH: I would be keen to look at modernism "in an expanded
field": to see it not only as painting practice but as artistic
self-reflection and self-determination — in which case you
can allow for a definition of modernism that does include
Duchamp or video art. Postmodern practices would then
need to be seen not as a break from modernism but as a

new type of modernism. But once again that does move us away from painting as a model.[3]

JE: Certainly the divisions in my lecture are changeable, and one way they might change would be to have postmodernism swallowed by a newly expanded modernism. But then I think you risk losing sight of the self-descriptions of some of the theorists whose work is predicated on the break between modernity and postmodernity. My lecture is meant not to stray too far from the range of understandings that theorists have of their own projects.

AS: May I ask something from a different angle? If we are talking about distinguishing practices in terms of chronology, rather than the many other criteria that are available, then I find your third category the most interesting but the least elaborated. You call it "political" but you include within it something that is ethical, something that is social, so you enter into various branches of social theory or social philosophy. The central issue is then how these hang together. In antiquity, as we know, they formed a whole, and especially in the Greek ideal of *charis*, ethics and politics were not separate.[4]

publisher

3. Paul Hegarty, "As Above, So Below: Informe/Abject/Sublime," in *La Bataille De Cent Ans — Cent Ans De Bataille.*
4. Michel Foucault, "The Care of the Self," in *The History of Sexuality*, trans. Robert Hurley, vol. 3 (New York: Pantheon, 1978).

Somehow, on the other hand, through the development of modernity, images gain a new power, while at the same time art becomes separated from the power of images. (I am thinking here of Edgar Wind's famous lectures, in which he argues the simultaneous decline of the dangerousness and thus the relevance of art, and the rise in power accorded to other types of images.)[5] At the same time, these bindings which somehow hold together politics, ethics, and aesthetics are displaced, and we end up with an art practice desperately trying to regain a power that it formerly possessed. Artists use all kinds of tricks, without success, to regain the "magical" power art has apparently lost.

JE: Perhaps we could talk about this piece by piece. First I would want to know: Do you think the genealogy that might unify the third portion of my lecture, tying the political to the moral and social, could be relevant to the project of this series?

AS: Sure, and it's not even a question of its relevance: the central problem would be the minute, meticulous, "gray" reconstruction of this process of power or, if you like, disempowerment. Rivera is an example of the kind of desperate effort I alluded to: an effort, somehow beyond art, to recapture some degree of relevance.

5. Edgar Wind, *Art and Anarchy* (Evanston, IL: Northwestern University Press, 1985).

JE: This is interesting to me, because I ended up with that third category, "Politics," through a series of negative criteria: in practical terms, texts that get called "social art history" can be identifiable as such partly by a relative absence of concerns that could be called formal or aesthetic. The third category is a grab bag of a particular sort, whose shape is determined by what presses in around it. What you say makes me think the category might have unity in a Foucauldian sense — I mean in light of his studies of the Greek origins of the concepts that animate the category.[6]

AS: Very much so: the last four or five years of Foucault's work are tightly focused on the interlinking of aesthetics and ethics, and even politics: first an aestheticization of existence, but more centrally an "art of life" as being partly ethical and partly aesthetic. This was done in the context of a return to certain issues of Greek political philosophy.

JE: If this Greek, or Foucauldian, genealogy might give the third category a certain unity that I hadn't suspected, then that coherence raises another kind of question that I would ask in reply: the problem of the coherence of my lecture as a whole. Specifically this raises the possibility that I would

6. *Foucault, Ethics: Subjectivity and Truth*, ed. Paul Rabinow, trans. Robert Hurley et al.(New York: New Press, 1997); *Foucault, Essential Works of Michel Foucault, 1954–1984*, ed. Paul Rabinow, trans. Robert Hurley et al., vol. 1 (New York: New Press, 1997); *Foucault, Technologies of the Self: A Seminar with Michel Foucault*, ed. Luther Martin et al. (Amherst: University of Massachusetts Press, 1988).

JE: … we might very well!

PH: … when the city has taken on the role of art producer, even when what it produces doesn't really matter, as long as it represents the community. That's the other end of Foucault's telescope, and it could work to balance things out.

So, how do you go back and theorize how these things have been theorized? Another part of this issue is the historical dimension of thinking about when modernism began. In other words, modernism might start in the Renaissance, but did anyone think of going back to the Renaissance before, say, 1850 (to take a notional point in the nineteenth century)? My answer is, fairly strongly, no. Then you have a telling of modernism which asks whether it began with the *Olympia*, the French Revolution, and so forth, but that telling of the story has its own story, and it travels around in France, and then to America. The capital of modernism is Paris at a certain moment, Vienna for a couple of days, and then New York. We don't have to decide whether that's true or not, but it shows the history of the telling of modernism's origins. Somewhere in that the telling of postmodernism fits, but I do not know how: postmodernism is in a position to reflect on itself and on modernism's telling of itself.

JE: From my point of view the most intriguing example of that problem is that there are strains within postmodernism's

telling of itself that would begin from the notion that postmodernism is not structured like a period. There is no reason in the logic of *Formless* why the story of post-modernism might not be extended back before Manet. That is a truly radical possibility — that postmodernism might be seen in any period that is minimally, retro-spectively, modernist — and I don't know how seriously that could be taken in a conversation that also turns on modernism's stories of itself.

PH: Terry Eagleton mentions the notion that Tristram Shandy has been said to be postmodern, that Rabelais is postmod-ern ... but they weren't postmodern before the 1980s.

JE: You don't even have to go back that far to run into post-modernism's allegedly nonperiodic structure. In Ireland, there's the enormous problem of *Finnegans Wake*, which is still nobody's principal book by Joyce (it's always *Ulysses*), and yet you can trawl that text for every generative concept of postmodernism.[8]

But what we're talking about is a logical difficulty in posi-ting a certain kind of history that depends on the notion of periods. A larger problem is whether or not this entire lecture series, which is posited on topographic metaphors — the "shape" of the twentieth century, the "structure" of

8. "What Have We Inherited? [on the place of Joyce in contemporary art]" in Christa-Mia Lerm
 Hayes, *Joyce in Art: Visual Art Inspired by James Joyce* (Dublin: Lilliput, 2004), 325-29.

essential movements — implies that one's principal interest is diachronics, genealogy. The problem is what has to be left out.

GH: I was wondering whether the whole modern–postmodern terminology doesn't refer to the theoretical, philosophical, social discourse on art rather than to the history of art in terms of its objects and practices. When you say that the postmodern approach may not have a location in time and space, that has to do more with the subjects of criticism rather than the objects of art: more to do with the phenomenology of art than with the phenomenon. I wonder if that may apply to modernism as well as postmodernism, so that whether or not things appear modernist may be a matter of the theoretical–critical approach.

JE: Immanence is one of modernism's inescapable terms, so at every moment when an object is considered as a modernist object, something is foreclosed: one is not allowed to escape from that presence.[9]

I wonder if we could find a way to continue talking about the limits of the historicizing approach, because they do not become visible in any even way, especially within modernism. If we were to take only, say, a later text of

9. The question of the possibility of a history of art "in terms of its objects and practices" became a central issue in the second lecture in the series, given by Richard Shiff.

Greenberg's, then we would have problems going forward in any of these directions because we would be compelled to comply with a philosophy of presence that cannot have recourse to any historical truths except after the fact, when it comes to assessing one's own "unwelcome judgments" (as Greenberg would say).[10] But outside of those texts there are all sorts of competing historical claims. If there is one idea that I have to swear allegiance to in this project, it is that considering topographies is not limiting in one category, one subject, any more than it is limiting in another. Genealogy constrains modernisms analogously to the way it constrains theories of skill. And so forth.

FH: And art history is itself a product of modernism; it can be traced to the birth of the modern museum, and the desire to classify objects and to separate them out for consideration. Either we regenerate the project of modernism in relation to artistic practice, something I would be interested in doing, or else art history must evaporate, as Craig Owens has argued.

JE: That and other evaporations will certainly become a theme in this series of books. One of the future speakers in the series has already objected to my inclusion of skill as a category; there will be questions of disciplinary allegiances

10. This is expanded in Elkins, *What Happened to Art Criticism?* (Chicago: Prickly Paradigm Press [distributed by University of Chicago Press], 2004).

throughout the series. But as a starting point, I would ask, What would be lost by positing these genealogies? Or perhaps, What choice do we have?

FH: Where do you stand on that, given that this genealogy is a modernist project?

JE: Well, it is modernist in some senses but not in others. My text is American-style sociology in some respects: the final section on skill is wholly outside modernism, and the terms the journalists whom I quote tend to use could be found in sixteenth- and seventeenth-century discourses on art. There is also material in the section on politics that is outside modernism, as Arpad has pointed out. But I also take your point: the motive for arranging history this way, and the value I am putting on the project, could be seen as modernist, but even then I am not convinced it is adequate to call it modernist. Classification is an academic pursuit, but it is shared by medieval theology and by Linnaeus, for example.

FH: Yet you did make a claim for neutrality, and so I am wondering how one might achieve that.

JE: Well, the lecture is not meant to be neutral in the way that an anthropologist from Mars would be neutral; however, I do pay attention to the quantity of literature that is produced in support of the different theories, and in that sense

I'm trying to be neutral the way an American quantitative sociologist might be. I was also trying not to say too much about what I think optimal genealogies might be.

FH: But that neutrality does make it feel like a modernist project.

JE: Perhaps. I think this exchange raises the most interesting problem of all: given that we're partly inside the problem we wish to describe, how can we tell that our investigation is compromised? Say I am partly impelled by modernism to think about history through genealogies: is it enough to just state that fact in order to cast doubt on the project? Maybe it's a dogma in the humanities that the demonstration of the double bind is sufficient to cast doubt on an inquiry — but I would note that not every attempt to explain something from the inside is ruined by that fact alone. Some speakers who are coming later in this series may not want to play the topographic game (I would prefer that to the genealogical game) at all; but if that is because they see this lecture as tainted by modernism, it will be necessary to ask if, in their own work, the stain of topography is wholly absent.

PH: Just to return to something that was said earlier: there is another possible story of stories, which is the institutional approach. Where is the center of the art world? That is a set of stories which is a possible category that does not fit with

the ones you are positing. It is a boring, pragmatic kind of story, one that Serge Guilbaut has built a career on. But that argument is a kind of postmodernist argument: that it's not all about formalism, or the aesthetic aspirations of art, but about how the art was received, how the institutional critique happened ...

JE: I would like to think, though, that to support a storytelling of that sort it would be necessary to refer to the systems of value that formed the consensus in any given case, and those systems would lead you back to the sorts of questions we have been discussing.

PH: Can I ask about skill? There are other things going on in skill than the ones you mention: there's modernist skill, conceptual skill ...

JE: I think that's definitely true. Because I am writing to some degree as a sociologist, I would need to know whether there is a broad enough use of those other senses of skill so that they could be heard above the millions who praise "skill" in the sense of realism. If the subject were skill per se, outside this occasion, then the various kinds of skill would certainly all be relevant. That is a live issue in art pedagogy, where people wonder whether conceptual skill (or skill at using a digital video editing software, or skill at managing a collaborative event) can be analogous to,

and even supplant, skill in the more popular or traditional sense of a toolbox of mimetic strategies.[11]

JJ: I was thinking about how the different distinctions you make in the first part of the paper can be matched to different philosophical innovations. The scholar who says modernism started with the Renaissance could be correlated with rationalism (so a philosopher might say); the claim that modernism started a hundred years later could be explained similarly; the phenomenological claim about modernism associated with Michael Fried could be correlated with empiricism.

JE: Just after the lecture, Tony O'Connor suggested that what I was calling "skill" could be explained best by recourse to R.G. Collingwood. I'd forgotten that connection, but I think he is right, and I am adding a note in the text. Still, Tony's comment and the parallels you've just made have me wondering about the limits of the utility of philosophic explanations. Collingwood is only connected by a thin thread to contemporary talk about skill: it's a pragmatic problem, and also a problem of discerning substantive differences between discourses.

11. Thus Howard Singerman, *Art Subjects: Making Artists in the American University* (Berkeley: University of California Press, 1999), wondered how he could have obtained an M.F.A. degree in sculpture without learning the fundamental techniques of sculptural media.

JJ: What is the motivation to call these innovations "births of modernism"? From the outside, speaking as a philosopher, I would say that modernism is made to stand for certain senses of innovation, and those senses can be assigned to philosophic moments. Modernism seems to be dependent on what one thinks the most significant innovation may have been.

JE: There is a difference between wanting to understand how modernism has been taken, and making a decision about it, based on an intellectual history that comes, at least nominally, from the outside. From a philosophic standpoint you have a series of problems that can perhaps be solved. But from a historical standpoint you have a series of misunderstandings that have histories. To me this is a problem that will shadow the entire series: everything having to do with modernism can be redescribed as a philosophic issue ... what needs to be raised is what an account of these historical phenomena that came from a philosophic standpoint could be used to do, and for whom they might be useful or apposite. Imagine a text in this lecture series, written by an aesthetician, with aesthetic categories, with historical examples appended to them. For whom is that the narrative of their experience, their place in history? That is the way I think I would resist the notion that this is a philosophic enterprise.

Writings by James Elkins

1. Books

The Poetics of Perspective (Ithaca, NY: Cornell University Press, 1994).
 Reviewed by Svetlana Alpers, *The Key Reporter* (Phi Beta Kappa)
 (Autumn 1995): 11.

The Object Stares Back: On the Nature of Seeing (New York: Simon and
 Schuster, 1996); paperback edition (New York: Harcourt Brace, 1997).

Our Beautiful, Dry, and Distant Texts: Art History as Writing (University
 Park: Penn State Press, 1997); paperback edition, with new preface
 (New York: Routledge, 2000).

On Pictures and the Words That Fail Them (Cambridge: Cambridge
 University Press, 1998).

What Painting Is (New York: Routledge, 1998). Excerpt published
 in Slovenian as "Brez korakov / Steplessness," *Likovne besede*
 [*Art Words*], trans. Mojca Zlokarnik, 55–56 (2001): 90–99.

*Why Are Our Pictures Puzzles? On the Modern Origins of Pictorial
 Complexity* (New York: Routledge, 1999).

The Domain of Images: On the Historical Study of Visual Artifacts
 (Ithaca, NY: Cornell University Press, 1999). Chapter 1 in Danish
 as "Kunsthistorie og billeder, der ikke er kunst," *Periskop* 9 (2000):
 49–80.

*Xi fang mei shu shi xue zhong de Zhongguo shan shui hua [Chinese
 Landscape Painting as Western Art History]*, trans. from English by Pan
 Yaochang and Gu Ling (Hangzhou: Zhongguo mei shu xue yuan chu
 ban she [National Academy of Art], 1999).

Pictures of the Body: Pain and Metamorphosis (Stanford, CA: Stanford University Press, 1999).

How to Use Your Eyes (New York: Routledge, 2000).

Pictures and Tears: A History of People Who Have Cried in Front of Paintings (New York: Routledge, 2001).

Why Art Cannot Be Taught: A Handbook for Art Students (Urbana: University of Illinois Press, 2001).

Stories of Art (New York: Routledge, 2002).

Six Stories from the End of Representation (Stanford, CA: Stanford University Press, 2005).

Visual Studies: A Skeptical Introduction (New York: Routledge, 2003).

On the Strange Place of Religion in Contemporary Art (New York: Routledge, 2004).

What Happened to Art Criticism? (Chicago: Prickly Paradigm Press [distributed by University of Chicago Press], 2003).

2. Articles

"Michelangelo and the Human Form: His Knowledge and Use of Anatomy," *Art History* 7 (1984): 176–86. Reviewed in *Leonardo* 18 (1985): 205. Reprinted in *Michelangelo: Selected Readings*, ed. William Wallace (New York: Garland, 1999), 652–66. In French as "Michel-Ange et la forme humaine. Sa connaissance et son utilisation de l'anatomie," in *l'Anatomie chez Michel-Ange: de la réalité à l'idéalité*, ed. Chiara Rabbi-Bernard (Paris: Hermann, 2003), 89–112.

"Piero della Francesca and the Renaissance Proof of Linear Perspective," *Art Bulletin* 69 (1987): 220–30.

"Remarks on the Western Art Historical Study of Chinese Bronzes, 1935–1980," *Oriental Art* 33 (Autumn 1987): 250–60.

"Two Conceptions of the Human Form: Bernard Siegfried Albinus and Andreas Vesalius," *Artibus et historiæ* 14 (1986): 91–106.

"Psychoanalysis and Art History," *Psychoanalysis and Contemporary Thought* 9 (1986): 261–98.

"Art History without Theory," *Critical Inquiry* 14 (1988): 354–78.

"Did Leonardo Develop a Theory of Curvilinear Perspective? Together with Some Remarks on the 'Angle' and 'Distance Axioms,' "

Journal of the Warburg and Courtauld Institutes 51 (1988): 190–96. Reprinted in *Leonardo's Science and Technology: Essential Readings for the Non-Scientist*, ed. Claire Farago (New York: Garland, 1999).

" 'Das Nüßlein beisset auf, Ihr Künstler!' Curvilinear Perspective in Seventeenth Century Dutch Art," *Oud Holland* 102 (1988): 257–76. Reply to E.H. Gombrich, *Critical Inquiry* 14 (1988): 893. Reply to Gombrich's response to the article "Art History without Theory."

"On the Arnolfini Portrait and the Lucca Madonna: Did Jan Van Eyck Have a Perspectival System?" *Art Bulletin* 73 (1991): 53–62.

"The Case against Surface Geometry," *Art History* 14, no. 2 (1991): 143–74.

"Mannerism: Deformation of the Stage," *Storia dell'Arte* 67 (1989): 257–62.

"Clarification, Destruction, Negation of Space in the Age of Neoclassicism" *Zeitschrift für Kunstgeschichte* 56, no. 4 (1990): 560–82.

"Comparative Studing [sic] on [sic] Chinese Painting and Eastern [sic] Painting, Written. [sic] by James Elkins Tvanslated [sic] by Feng Lemin" [in Chinese except for the title; abbreviated version of "Chinese Landscape Painting as Western Art History"], *History and Theory of Fine Arts, Beijing* 2 (1991): 103–11.

"Uccello, Duchamp: The Ends of Wit," *Zeitschrift für Ästhetik und allgemeine Kunstwissenschaft* 36 (1991): 199–224 and 10 plates [published 1993].

"An Ambilogy of Painted Meanings," *Art Criticism* 8, no. 2 (1992): 26–35.

"On Modern Impatience," *Kritische Berichte* 3 (1991): 19–34.

"On the Impossibility of Stories: The Anti-Narrative and Non-Narrative Impulse in Modern Painting," *Word and Image* 7, no. 4 (1991): 348–64.

"Studio Art Critiques as Seductions," *Journal of Aesthetic Education* 26, no. 1 (1992): 105–107.

"The Snap of Rhetoric: A Catechism for Art History," *SubStance* 68 (1992): 3–16.

"Renaissance Perspectives," *Journal of the History of Ideas* 53, no. 2 (April–June 1992): 209–30.

"On the Conceptual Analysis of Gardens," *Journal of Garden History* 13, no. 4 (1993): 189–98.

"The 'Fundamental Concepts' of Pictures," *Journal of Speculative Philosophy* 6, no. 2 (1992): 143–51.

"On the Unimportance of Alchemy in Western Painting," *Konsthistorisk tidskrift* 61 (1992): 21–26.

"From Copy to Forgery and Back Again," *British Journal of Aesthetics* 33, no. 2 (1993): 113–20.

"On Visual Desperation and the Bodies of Protozoa," *Representations* 40 (1992): 33–56.

"The Drunken Conversation of Chaos and Painting," *Meaning* 12 (1992): 55–60.

"The Unease in Art History," *Qui parle* 6, no. 1 (Fall–Winter 1992): 113–33.

"Style," in *The Grove Dictionary of Art* (New York: Grove Dictionaries, 1996).

"Abstraction's Sense of History: Frank Stella's Working Space Revisited," *American Art* 7, no. 1 (Winter 1993): 28–39.

"The Failed and the Inadvertent: The Theory of the Unconscious in the History of Art," *International Journal of Psychoanalysis* 75, no. 1 (1994): 119–32. Revised version (2001) online at www. AcademyAnalyticArts.org/cnelkins.html.

"A Hagiography of Bugs and Leaves: On the Dishonesty of Pictured Religion," *Journal of Information Ethics* 2, no. 2 (1993): 53–70. Reprinted in *Religion and the Arts* 1, no. 3 (1997): 73–88.

"Art History and the Criticism of Computer-Generated Images," *Leonardo* 27, no. 4 (1994): 335–42 and color plate. Also in electronic format in *SIRS Renaissance* (CD-ROM) (Boca Raton, FL: Social Issues Research Series, 1995).

"On Monstrously Ambiguous Paintings," *History and Theory* 32, no. 3 (1993): 227–47.

"What Really Happens in Pictures? Misreading with Nelson Goodman," in *Word and Image* 9, no. 4 (1993): 349–62.

"The Question of the Body in Mesoamerican Art," *Res* 26 (1994): 113–24.

"Parallel Art History/Studio Program," *Art Journal* (1995): 54–57.

"There Are No Philosophic Problems Raised by Virtual Reality," *Computer Graphics* 28, no. 4 (1994): 250–54.

"Art Criticism," in *The Grove Dictionary of Art* (New York: Grove Dictionaries, 1996).

"Marks, Traces, Traits, Contours, Orli, and Splendores: Nonsemiotic Elements in Pictures," *Critical Inquiry* 21 (1995): 822–60.

"Different Horizons for the Concept of the Image," *Zeitschrift für Ästhetik und allgemeine Kunstwissenschaft* 43, no. 1 (1998): 29–46.

"Between Picture and Proposition: Torturing Paintings in Wittgenstein's Tractatus," *Visible Language* 30, no. 1 (1996): 73–95.

"On the Impossibility of Close Reading: The Case of Alexander Marshack," *Current Anthropology* 37, no. 2 (1996): 185–226.

"Art History and Images That Are Not Art," *Art Bulletin* 77, no. 4 (1995): 553–71.

"Histoire de l'art et pratiques d'atelier," translation of "Why Art Historians Should Draw: The Case for Studio Experience," *Histoire de l'art* 29–30 (1995): 103–12.

"Why Are Our Pictures Puzzles? Some Thoughts on Writing Excessively," *New Literary History* 27, no. 2 (1996): 271–90.

"Is It Still Possible to Write a Survey of Art History?" *Umeni* (Prague) 43 (1995): 309–16.

"La Persistance du 'tempérament artistique' comme modèle: Rosso Fiorentino, Barbara Kruger, Sherrie Levine," *Ligeia* 17–18 (October 1995–June 1996): 19–28.

"What Are We Seeing, Exactly?" contribution to a forum on digital images, *Art Bulletin* 79, no. 2 (1997): 191–98. Response to a letter to the editor, by Charles Rhyne, "Digital Culture and Art History: High-Quality Images Are Available Now," *Art Bulletin* 80, no. 1 (1998): 194.

"A Thought Experiment, for a Book to Be Called *Failure in Twentieth-Century Art* [critical review of David Carrier's work]," *Journal of Aesthetic Education* 32, no. 4 (1998): 43–51.

"Logic and Images in Art History," response to Peter Galison's *Image and Logic*, in *Perspectives on Science* 7, no. 2 (1999): 151–80.

"On Some Useless Images [in Physics]," *Visual Resources* 17 (2001): 147–63.

"Why It Is Not Possible to Write the Art History of Non-Western Cultures," translated into Chinese by Ding Ning, in *Mei yuan/Journal of the Lu Xun Academy of Fine Arts* (Beijing) 3 (2002): 56–61. Reprinted in Slovenian and English in *Minulost'v Prítomnosti: Súcasné umenie a umeleckohistorcké myty / The Past in the Present: Contemporary Art and Art History's Myths*, ed. Ján Bakos (Bratislava: Nadácia-Centrum Súcasného Umenia, 2002 [sic 2003]), 229–55.

"What Is the Difference between the Body's Inside and Its Outside?" and "The Limits of Phenomenology: On the Inconceivable and the Unrepresentable in Skin and Membrane Metaphors," in *The Imagination of the Body and the History of Bodily Experience*, ed. Shigehisa Kuriyama (Kyoto: International Research Center for Japanese Studies, 2001), 9–16, 261–67.

"The End of the Theory of the Gaze," in *Knowing Bodies, Feeling Minds: Embodied Knowledge in Arts Education and Schooling*, ed. Liora Bresler (Amsterdam: Kluwer, forthcoming). Revised version in Spanish, "El final de la teoría de la mirada," trans. Noelia García Pérez, in *Debats* 79 (2002–2003): 76–89.

"What Does Peirce's Sign System Have to Say to Art History?" *Culture, Theory, and Critique* 44, no. 1 (2003): 5–22.

"Preface to the book A Skeptical Introduction to Visual Culture," *Journal of Visual Culture* 1, no. 1 (2002): 93–99.

"Four Ways of Measuring the Distance between Alchemy and Contemporary Art," *Hyle* 9, no. 1 (2003): 105–18.

"From Bird-Goddesses to Jesus 2000: A Very, Very Brief History of Religion and Art," *Thresholds* [MIT] 25 (2002): 76–83. Includes an exchange with Caroline Jones.

"Ako je mozné písat' o svetovom umení?" [How Is It Possible to Write about the World's Art?] *Ars* [Bratislava] 2 (2003): 75–91, with English summary provided by the editors.

"Words and Images Most Severely Distorted," *Circa* [Dublin] 204 (2003): 55–57.

"The State of Irish Art History," *Circa* [Dublin] 106 (2003): 56–59.

"What Have We Inherited? [On the place of Joyce in contemporary art]," in Christa-Mia Lerm Hayes, *Joyce in Art: Visual Art Inspired by James Joyce* (Dublin: Lilliput, 2004), 325–29.

"Two Forms of Judgement: Forgiving and Demanding (The Case of Marine Painting)," *Journal of Visual Art Practice* 3, no. 1 (2004): 37–46.

"Preface" to Eduardo Kac, *Telepresence and Bio Art: Networking Humans, Rabbits, and Robots* (Ann Arbor: University of Michigan Press, 2005).

"Why Nothing Can Be Accomplished in Painting, and Why It Is Important to Keep Trying," *Circa* 109 (2004): 38–41.

3. Selected Book Reviews, Catalogues, and Miscellaneous Items

"Three Questions for the New York School," in *Modern American Painting from the NYU Art Collection*, exhibition catalog (Cork, Ireland: Glucksman Gallery, 2004), 11–18.

Review of David Summers, *Real Spaces*, in *Art Bulletin* 86, no. 2 (2004): 373–80.

Letter on the state of art history, *Chronicle of Higher Education*, September 19, 2003, B4.

"Visual Culture: First Draft," review of *Iconoclash!* ed. Bruno Latour and Peter Weibel, in *Art Journal* 62, no. 3 (2003): 104–107.

Review of Alberto Manguel, *Reading Pictures* (Toronto: Knopf Canada, 2000), in *Letters in Canada* 72, no. 1 (2002–2003): 362–63.

"Nine Modes of Interdisciplinarity in Visual Studies," reply to Mieke Bal, "Visual Essentialism and the Object of Visual Culture," *Journal of Visual Culture* 2, no. 2 (2003): 232–37. Forthcoming in Spanish in Estudio visuales.

"Rapatronic Photographs of Atomic Tests," in *After and before: Documenting the A-bomb* (New York: PPP Editions, 2003).

"Ten Reasons Why E.H. Gombrich Is Not Connected to Art History," posted on the Gombrich Web site, at http://www.gombrich.co.uk/ under "Forum."

Review of David Hockney, *Secret Knowledge* (New York: Viking, 2001), on the College Art Association review site at http://www.caareviews.org/hockney.html.

Review of the NYU conference on David Hockney's book *Secret Knowledge*, in *Circa* 99 (Spring 2002): 38–39.

"Who Owns Images: Science or Art?" review of an MIT conference, "Image and Meaning," June 2001, in *Circa* 97 (2001): 36–37.

James Elkan [sic], "The Transcendence of Art: An Essay on the Epileptic Autistic Pakistani Artist Sadia Sheikh, and Her Great- Great-

Great- Grandfather," exhibition catalog (Lahore, Pakistan: Lahore Businessmen Association for Rehabilitation of Disabled, 2002).

"Renouncing Representation," essay in *Marco Breuer: Tremors, Ephemera*, exhibition catalog (New York: Roth Horowitz, 2000).

Review of *Picturing Science, Producing Art*, ed. Caroline Jones and Peter Galison, in *Isis* 97, no. 9 (2000): 318–19. (Version truncated by *Isis*.)

Review of *Theories of Art Today*, ed. Noël Carrol, in *Journal of Aesthetic Education* 35, no. 2 (2001): 119–21.

Review of Steven Mansbach, *Modern Art in Eastern Europe*, in *Art Bulletin* 82, no. 4 (2000): 781–85.

"Response [to Anthony Alofsin's letter regarding the review of Mansbach's *Modern Art in Eastern Europe*]," *Art Bulletin* 84 (2002): 539.

Review of Eileen Reeves, *Painting the Heavens: Art and Sciences in the Age of Galileo* (Princeton, NJ: Princeton University Press, 1997), in *Zeitschrift für Kunstgeshcichte* 62 (1999): 580–85.

"Precision, Misprecision, Misprision," reply to Thierry de Duve, in *Critical Inquiry* 25, no. 1 (1998): 169–80.

"Real Disquietude/Un verdadero desasosiego," exhibition catalog for Pablo Helguera, *Estacionamientos (Parking Zones)* (Mexico City: Talleria espacio cultural, 1998).

Reply to LeRoy McDermott, "Self-Representation in Upper Paleolithic Female Figurines," in *Current Anthropology* 37, no. 2 (1996): 255–58.

"What Do We Want Pictures to Be?" *Critical Inquiry* 22 (1996): 590–602.

"What Is Alchemical History?" *Konsthistorisk tidskrift* 64, no. 1 (1995): 51–53.

Review of Hal Foster, *Compulsive Beauty* (Cambridge, MA: MIT Press, 1993), in *Art Bulletin* 76, no. 3 (1994): 546–48.

Reply to Ellen Handler Spitz (responding to the review, above), *Art Bulletin* 77, no. 2 (1995): 342–43.

"Before Theory," review of Whitney Davis, *Masking the Blow* (Berkeley, CA: University of California Press, 1992), in *Art History* 16, no. 4 (1993): 647–72.

Review of Barbara Stafford, *Body Criticism* (Cambridge, MA: MIT Press, 1991), in *Art Bulletin* 74, no. 3 (1992): 517–20.

Review of Martin Kemp, *The Science of Art* (New Haven, CT: Yale University Press, 1990), in *Zeitschrift für Kunstgeschichte* 54, no. 4 (1991): 597–601.

"Signs of Religion," exhibition catalog, School of the Art Institute of Chicago, Gallery 2, fall 1991.

"Castillon's Problem," *Journal of Recreational Mathematics* 22, no. 3 (1991): 224.

4. Interviews

Luigi Prestinenza, interview for CPA, Channelbeta, *Canale d'Informazione sull'Architettura Contemporanea*, September 2004.

Robert Lozar, "In popolnoma pozabim, kdo sem/And I Completely Forget Who I Am [in Slovenian]," *Likovne Besede* (Ljubljana) 63–64 (2003): 81–93.

Deanna Isaacs, "Critical Condition [interview about *The Visual Art Critic*]," Chicago Reader, December 6, 2002, section 2, p. 22.

Tom Valeo, "In the Eye of a Ruthless Beholder: James Elkins Sees Where Artists Go Wrong," *Citytalk*, April 1, 2002.

Interview about *Pictures and Tears, The Connection*, National Public Radio, December 13, 2001, http://www.theconnection.org/archive/2001/12/1213b.shtml.

Interview about *How to Use Your Eyes, The Connection*, National Public Radio, February 7, 2001, http://www.theconnection.org/archive/2001/02/0207b.shtml.

Margaret Corcoran, "Open to Criticism," *Circa* 94 (2000): 26–29.

Rick Kogan, "20/20 Insight: An Art Institute Professor Finds Worlds of Meaning in the Mundane," *Chicago Tribune Sunday Magazine*, cover story, October 8, 2000.

Scott Heller, "A Maverick Art Historian Examines His Field's Idiosyncrasies and Blind Spots," *Chronicle of Higher Education*, June 25, 1999, A17–18.

Tamara Bissell, "Interview with James Elkins," *Umeni* (Prague) 46, nos. 1–2 (1998): 145–52.

Review of Lawrence Wright, *Perspective in Perspective*, in *Design Book Review* (Fall 1986): 55.

Index

189